W9-AVA-047

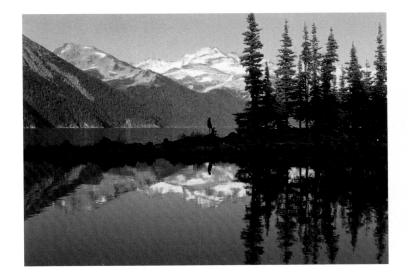

BRITISH COLUMBIA

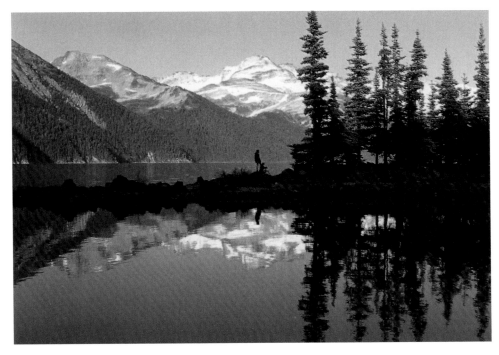

WHITECAP BOOKS

The information in this book is true and complete to the best of our knowledge. All
recommendations are made without guarantee on the part of the author or Whitecap
Books Ltd. The author and publisher disclaim any liability in connection with the use
of this information. For additional information please contact Whitecap Books Ltd.,
351 Lynn Avenue, North Vancouver, BC V7J 2C4.

Cover and book design by Steve Penner

Text by Tanya Lloyd
Edited by Elaine Jones
Proofread by Lisa Collins
Photo editing by Pat Crowe
Front cover photograph by Ron Watts/First Light
Back cover photograph by Adam Gibbs

Printed and bound in Canada by Friesens, Altona, Manitoba

National Library of Canada Cataloguing in Publication Data

Lloyd, Tanya, 1973–

British Columbia

ISBN 1-55110-521-7 (bound).—1-55285-593-7 (pbk).

1. British Columbia—Pictorial works. I. Title. II. Series:
Lloyd, Tanya, 1973.
FC3812.L66 199766 1999971.1'04'022266 1999C96-919742-0
F1087.8.L66 1997

The publisher acknowledges the financial support of the financial support of the Government of
Canada through the Book Publishing Industry Development Program for our publishing activities.

**For more information on the Canada Series and other Whitecap
Books titles, please visit our web site at www.whitecap.ca.**

On one side of British Columbia, waves from Japan crash against the shores of Long Beach. On the other, the Rocky Mountains rise above alpine meadows. B.C. is Canada's third-largest province—four Great Britains, two Japans, or nine Jamaicas would fit within its borders. Its diverse geography includes more than 7000 kilometres of coastline, towering rainforests, secluded wetlands, and barren ranges. In the Bella Coola valley, lush forest surrounds roaring rivers; in the Okanagan, rattlesnakes wind through a pocket desert.

This province has Canada's fastest-growing population, and as people continue to swell the towns and cities, attention has fallen on the need to preserve its diversity. Provincial and national parks protect more than 2000 species of flowering plants, as well as Canada's widest array of animal habitat. Sharing the parks with wildlife such as grizzlies and bald eagles are human adventurers. They scale the Bugaboo spires, ski the powder of Mount Atlin, and canoe the still lakes of the Cariboo, finding some of the most stunning natural settings in the world.

But B.C. is not all wilderness. First Nations people have lived here for more than 12,000 years, and ever since fur trader Alexander Mackenzie became the first white man to cross the continent in 1793, the province has endured a turbulent history. The fur trade, the gold rush, and the building of the CPR lured thousands of people. Today there are reminders of these wild days in boomtowns of the Interior such as Barkerville and Fort Steele. There are also modern metropolises, including Vancouver, the province's largest city, and Victoria, the capital. The mild winters and community atmosphere of these cities have earned residents a reputation for easygoing friendliness and have prompted eastern Canadians to dub southern B.C. "lotus land."

To protect their lifestyles and the province's natural resources, British Columbians continue to work to find a balance in the province. Increasingly, industry, environmentalists, the public, and the provincial government are cooperating to manage natural resources and protect the array of forests, marshes, and mountain peaks that hold the promise of a prosperous future. Through continued efforts, B.C. hopes to uphold its motto: *splendor sine occasu*, splendor without diminishment.

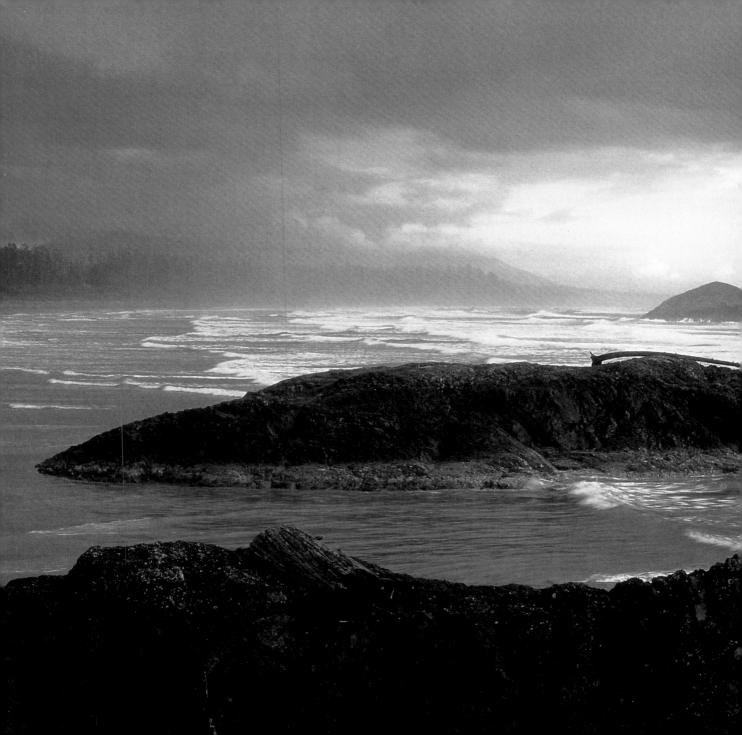

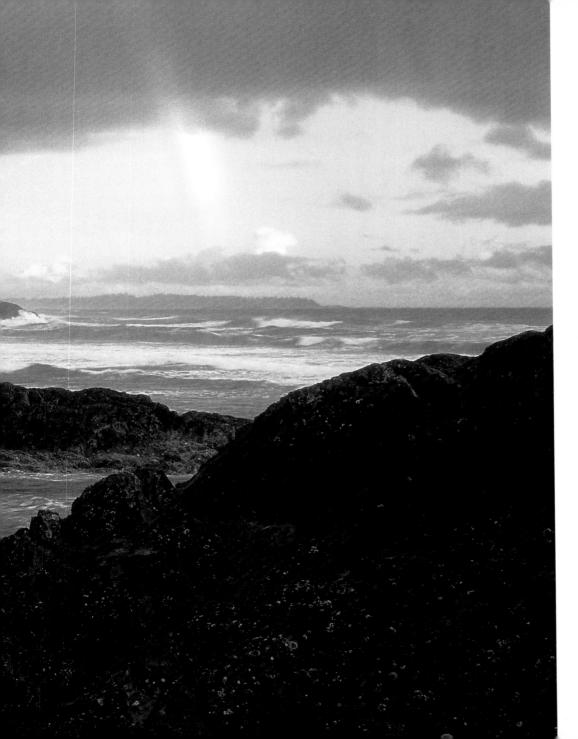

Waves sweep Long Beach, an 11-kilometre stretch of sand and surf that forms part of Pacific Rim National Park on Vancouver Island.

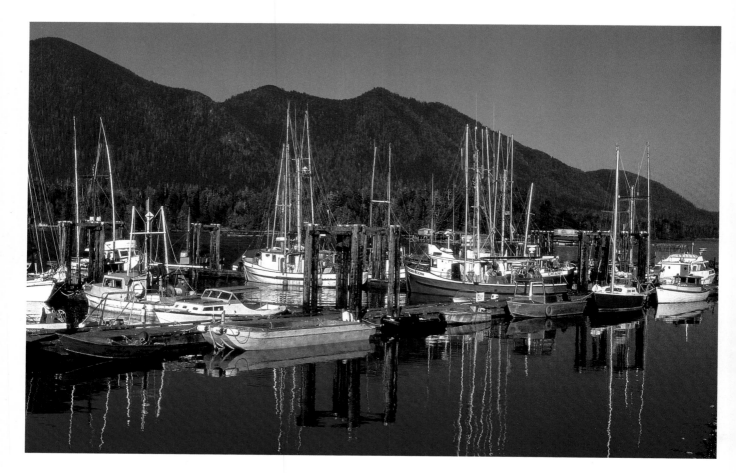

The small town of Tofino on Vancouver Island's west coast is a base for both fishing and whale watching. In the spring, thousands of grey whales pass near the shore on their way to Alaska.

The West Coast Trail was originally built for the workers who serviced the telegraph wire between Victoria and Cape Beale. It was improved in the early 1900s to allow rescuers to reach shipwreck survivors. Now, more than 9000 hikers each year come from all over the world to follow the 72-kilometre route past the old-growth rainforest and rocky shoreline.

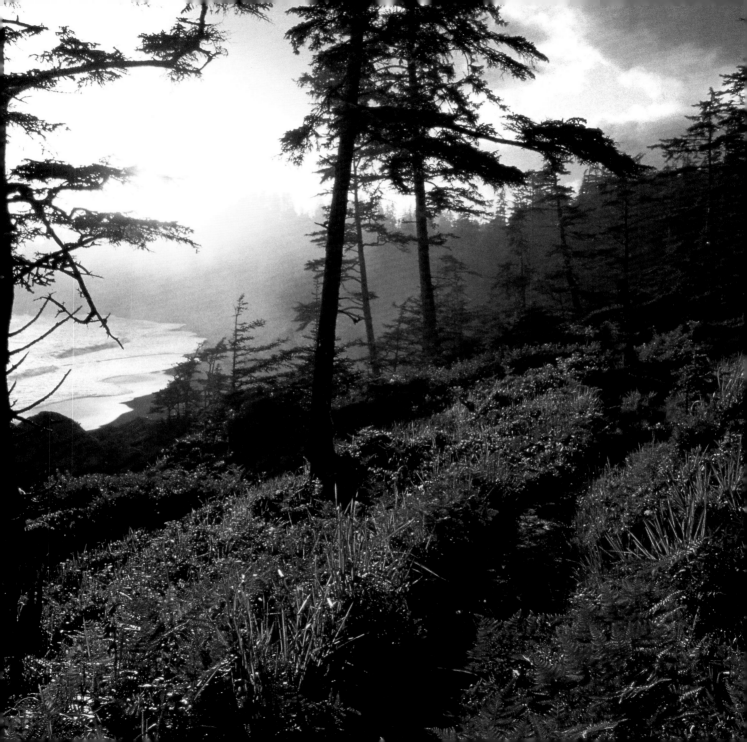

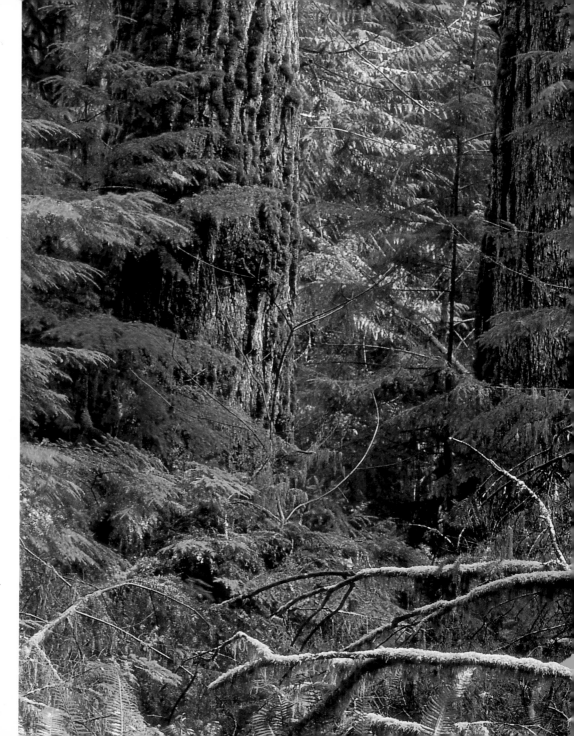

MacMillan Park's Cathedral Grove is aptly named—branches arch into the sky to screen out the sunlight. These 800-year-old trees survived a forest fire that destroyed their surroundings about 300 years ago. Now, the tallest Douglas fir is more than 75 metres high.

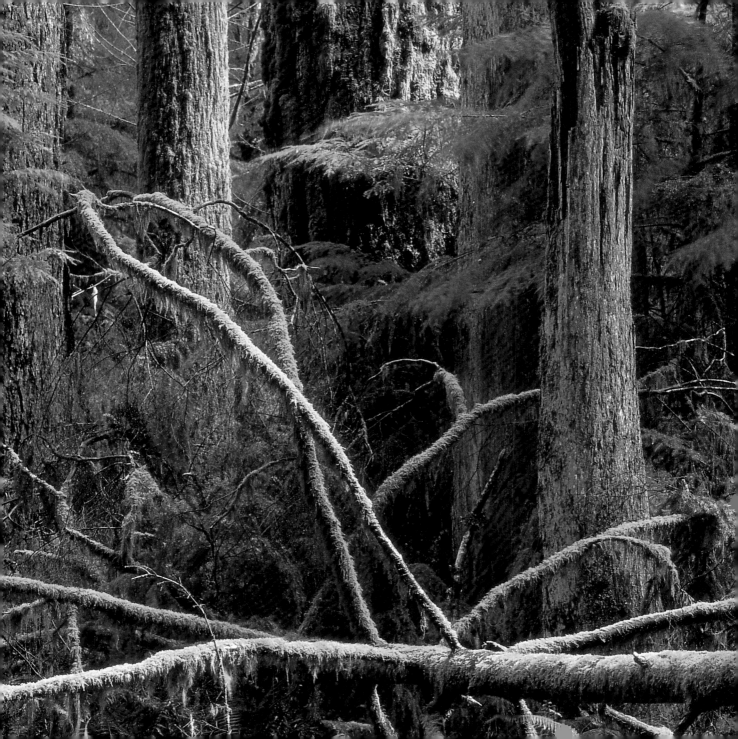

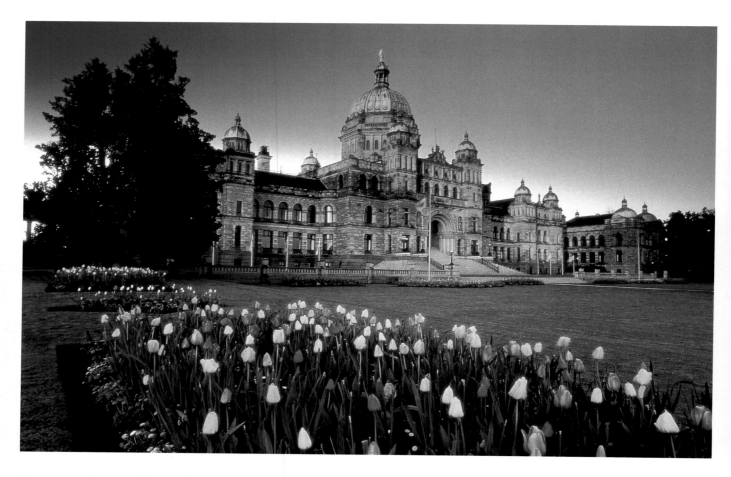

The copper domes of the Parliament
Buildings tower over Victoria's Inner
Harbour. The architecture and paintings
of the interior have been restored, and
tours are offered throughout the year.

High tea is a tradition at the Empress Hotel in Victoria, where
residents have been called "more British than the British." The
hotel was built by the Canadian Pacific Railway in 1907.

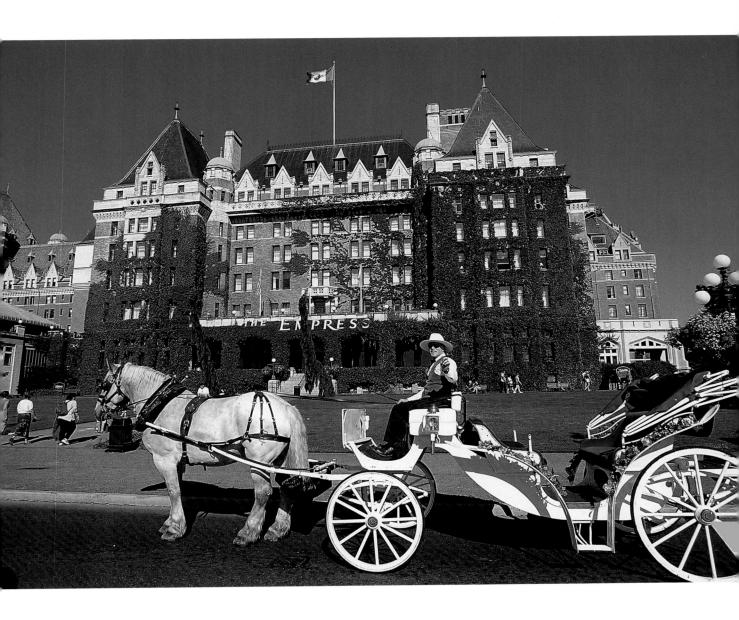

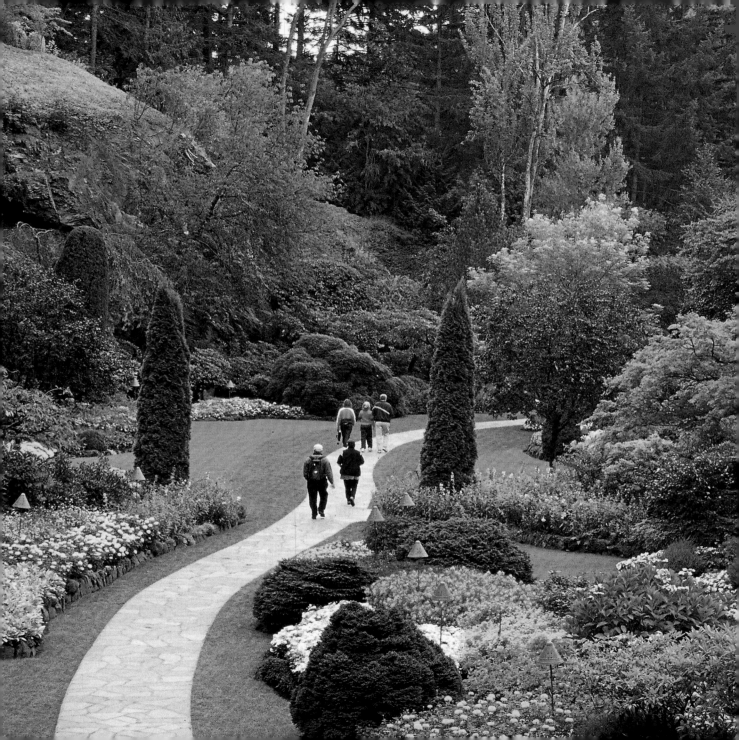

Who would guess that this was once a limestone quarry? Butchart Gardens, on Vancouver Island's Saanich Peninsula, was originally created by Jenny Butchart, wife of the quarry owner. Now more than one million plants dazzle visitors.

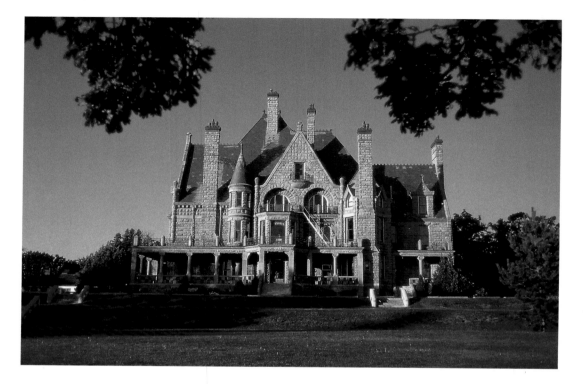

On a Victoria hilltop, nineteenth-century tycoon Robert Dunsmuir envisioned his ideal home. He died before Craigdarroch Castle was completed in 1898, but he left his love of castles behind. His wife lived here until her death and their son James Dunsmuir built Victoria's second castle, now part of Royal Roads University.

The sand and surf at French Beach Provincial Park near Victoria make it a favourite with families and picnickers, but visitors are warned not to venture onto the rocks, where sudden waves might sweep them away.

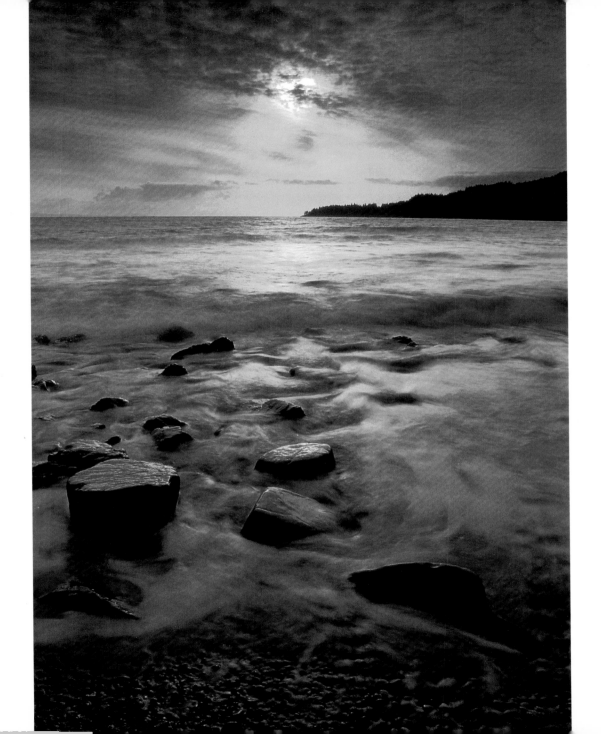

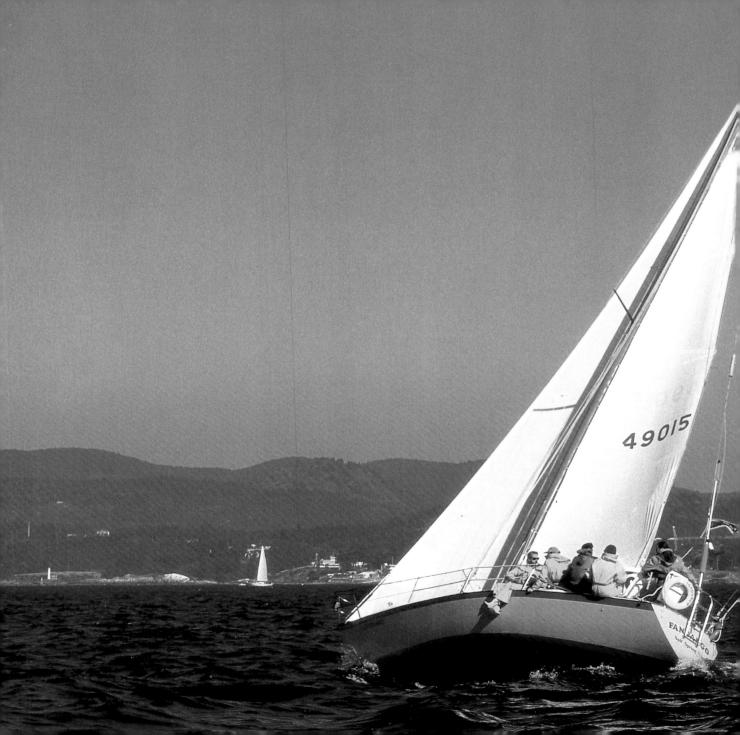

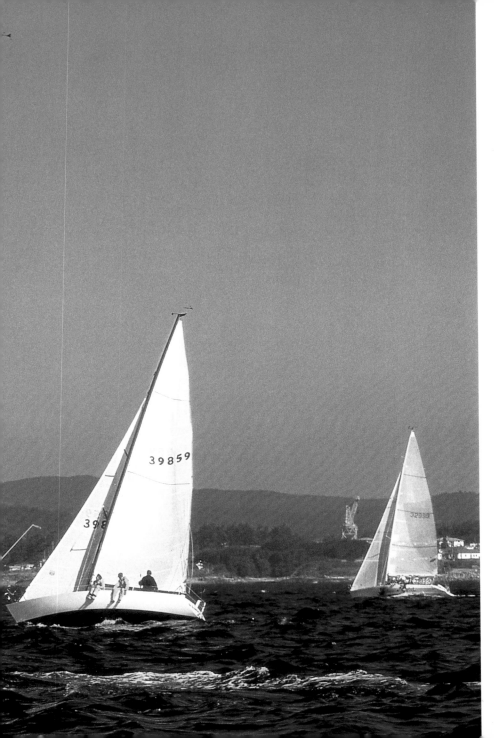

Hundreds of sails are raised each May as competitors in the Swiftsure Yacht Classic race from Victoria to Cape Beale and back again.

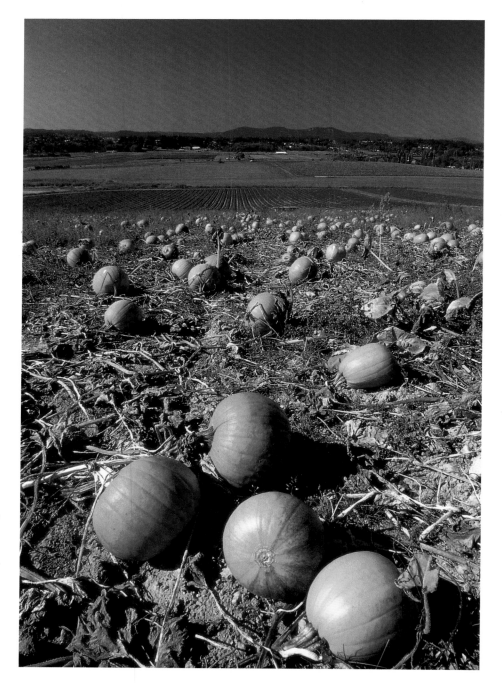

Despite the continued growth of nearby Victoria, there's still room on the Saanich Peninsula for farmland—whether it's a spring crop of daffodils or this autumn pumpkin patch.

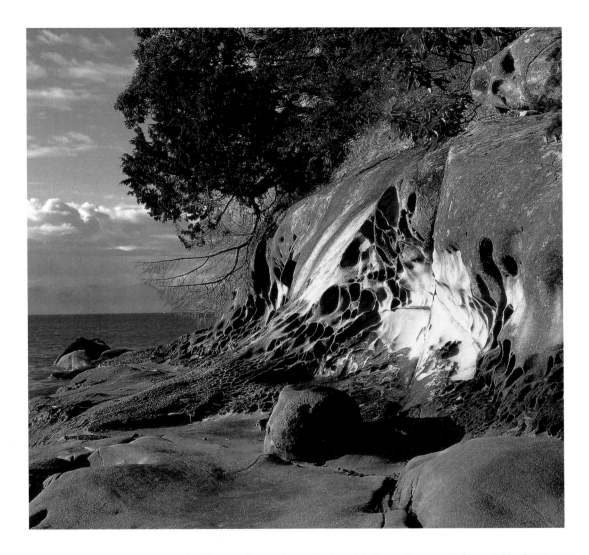

Sandstone formations distinguish Coon Bay on Galiano Island. At low tide, visitors can walk from the bay to a small islet offshore.

Overleaf –
B.C.'s massive superferries pass in front of Mayne Island at the mouth of Active Pass. The boats run year-round between Tsawwassen, on the mainland, and Swartz Bay on Vancouver Island.

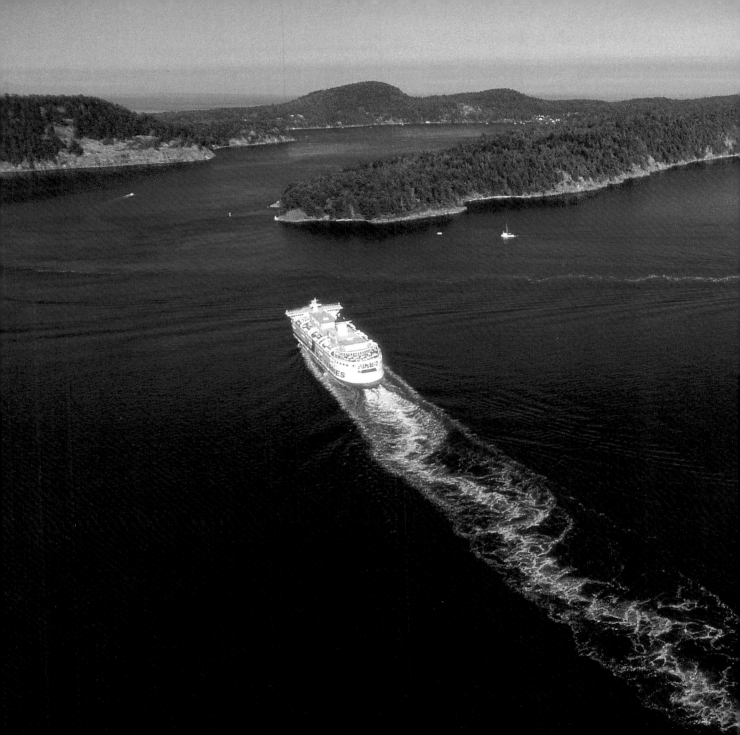

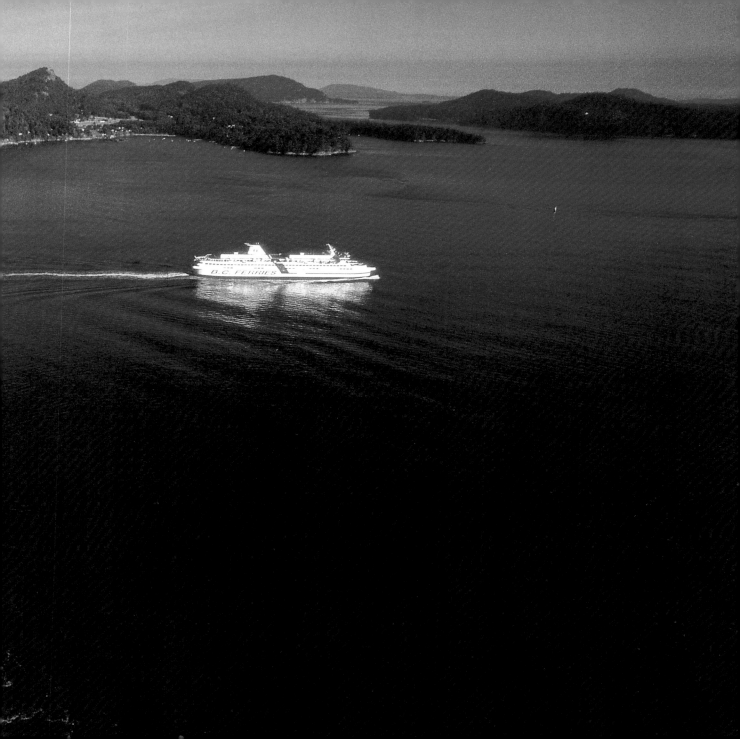

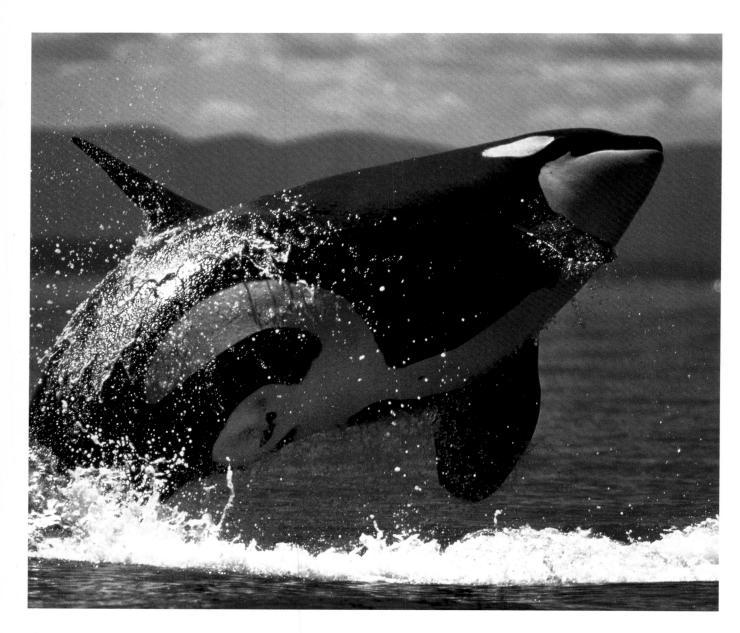

The orca, or killer whale, is one of the most easily recognized whales and can occasionally be seen at close quarters as it ventures into small bays and inlets. This orca was spotted between B.C. and Washington State.

Mayne Island was one of the first Gulf Islands to be settled. The area is rich with heritage homes and farms.

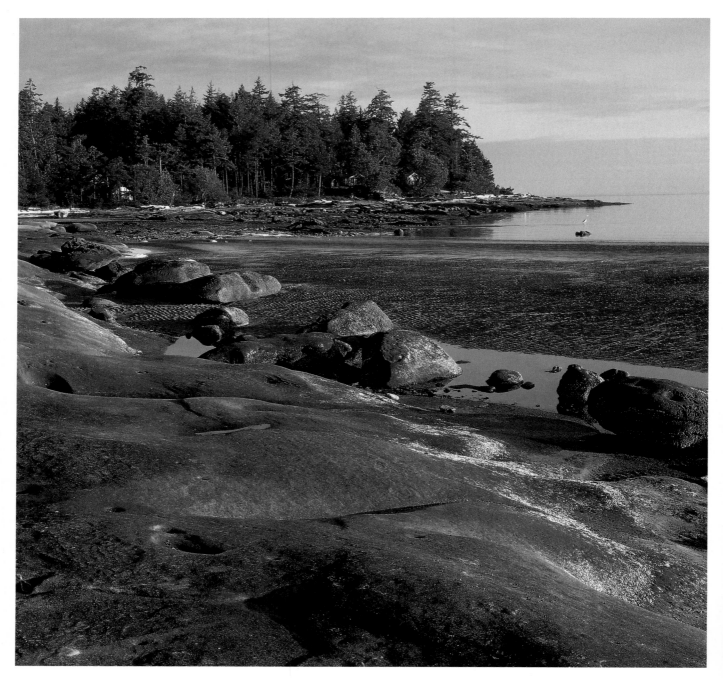

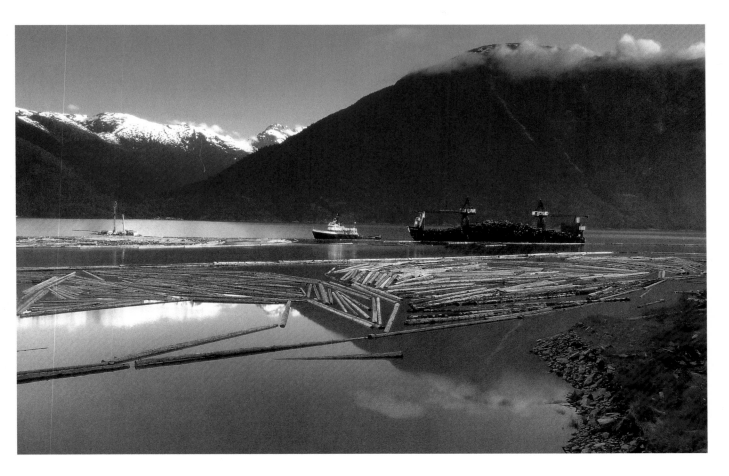

Log booms float on the glassy water of Bella Coola Harbour.

Once owned by the B.C. Whaling Company, the property above Whaling Station Bay on Hornby Island is now the idyllic site of waterfront homes and summer cottages. The bay's sandstone slabs soak up the sun and make it a popular spot for sunbathers.

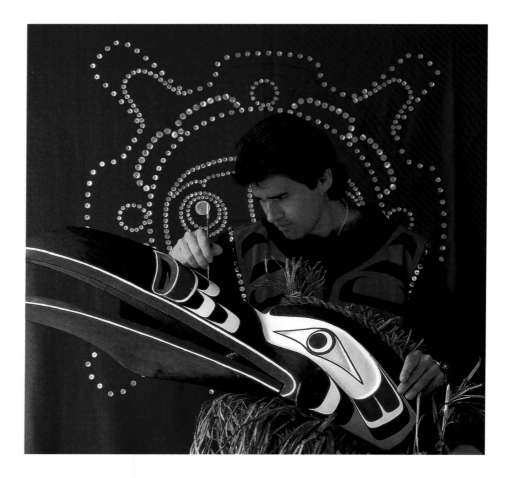

Artist and dancer Randy Bell puts the finishing touches on a ceremonial dance mask. He is a member of the Kwagiulth people, whose traditional lands are on Vancouver Island.

A sailboat rests quietly along the coast of Princess Royal Island, off the west coast near Kitimat.

OVERLEAF –
Sunset silhouettes one of more than 150 islands and islets that make up the Queen Charlotte Island Archipelago, near Murchison Island in the South Moresby National Park Reserve.

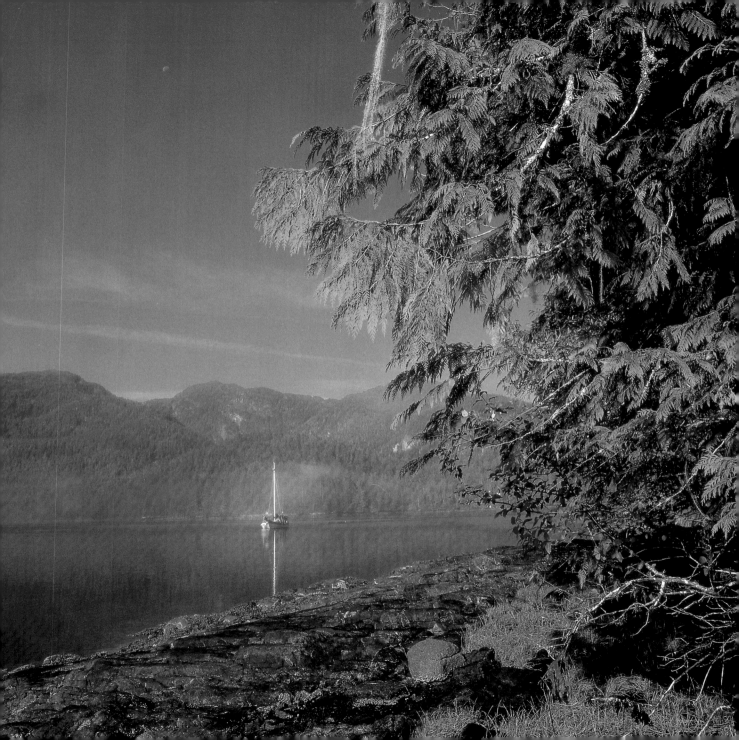

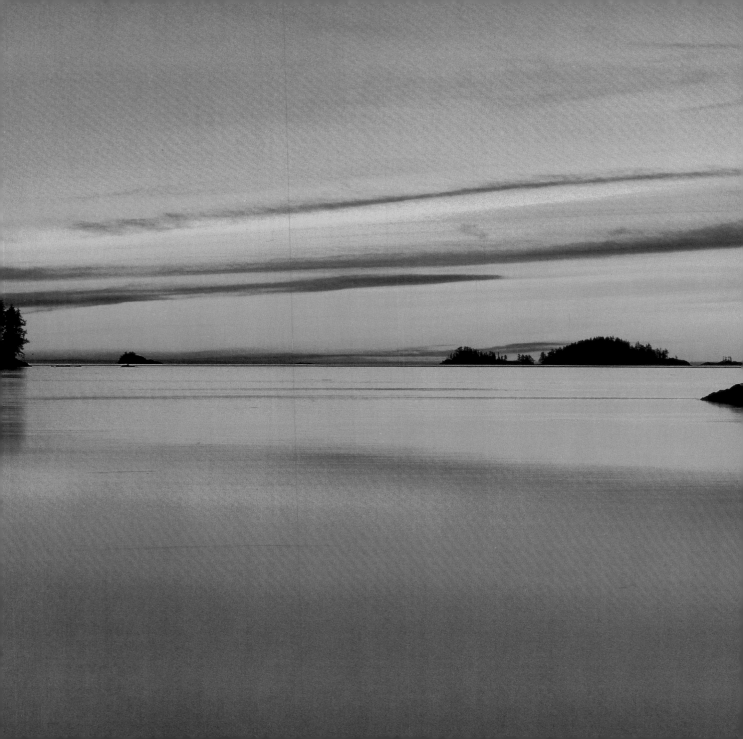

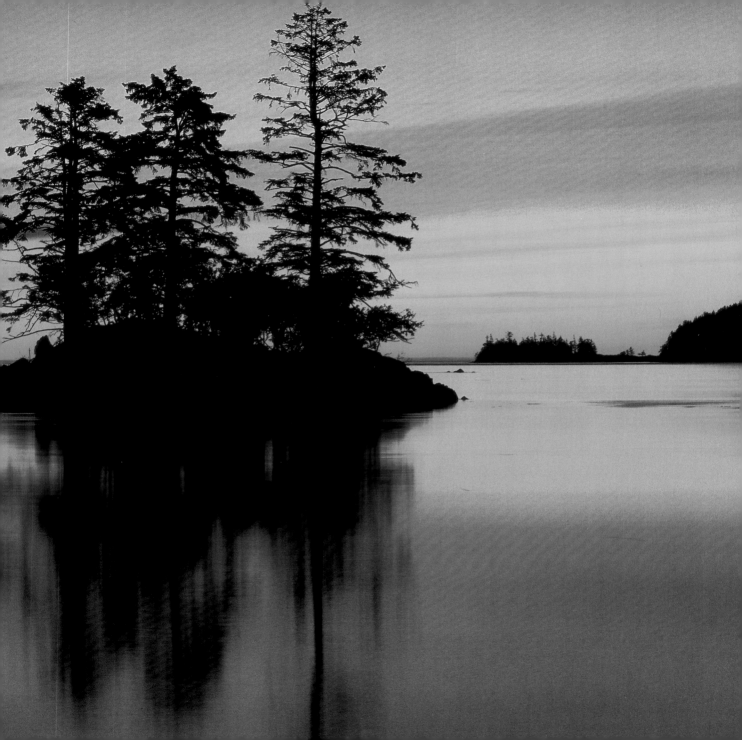

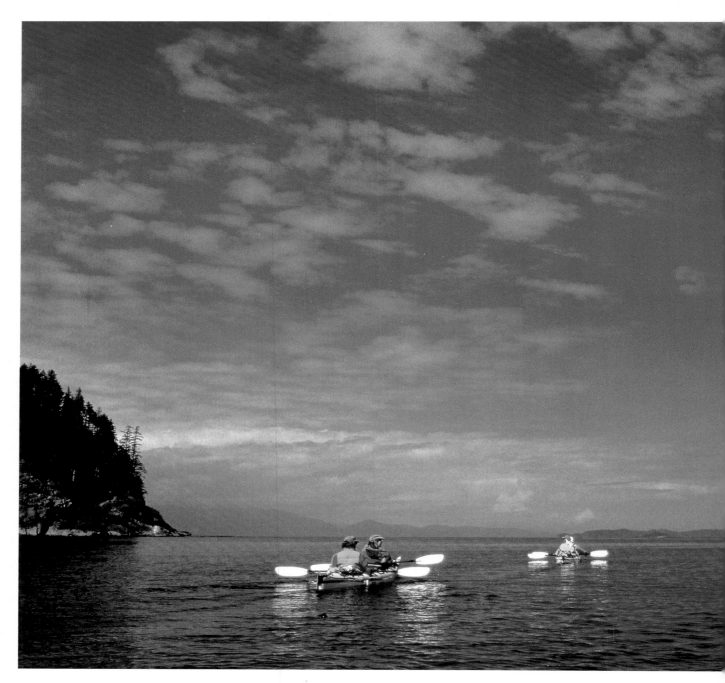

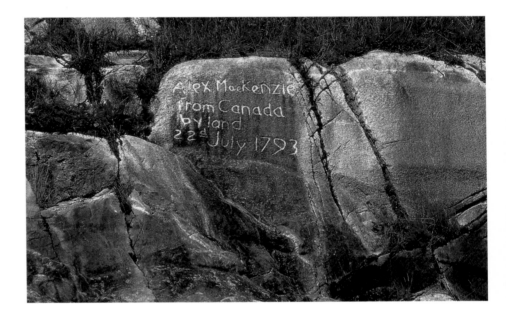

In 1793, Alexander Mackenzie and his native guides canoed down the Bella Coola River to arrive on the west coast. He was the first white man to make the journey across the continent to the Pacific.

Kayakers paddle near the shore of one of the Queen Charlotte Islands, where the rainforest holds hundreds of bird and animal species, and some of the world's tallest trees.

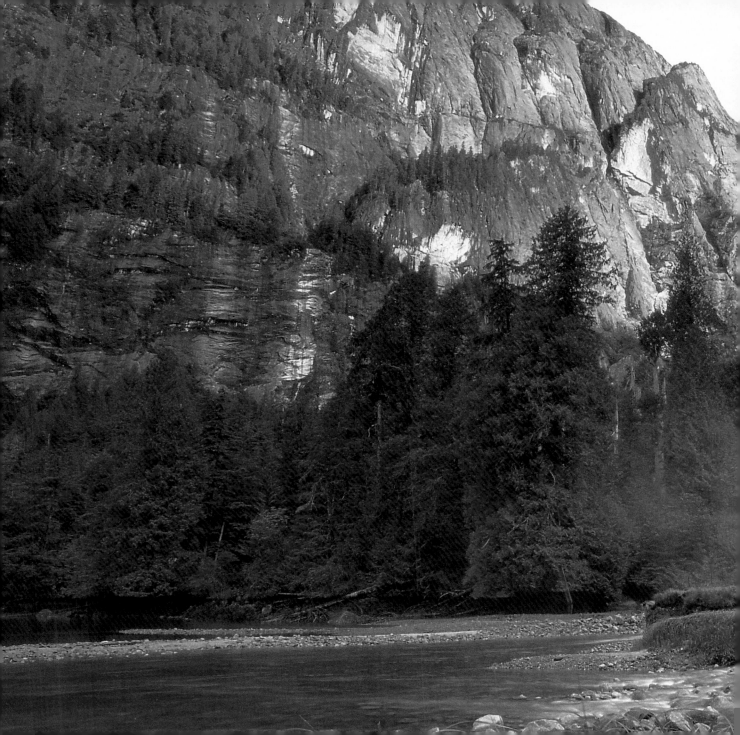

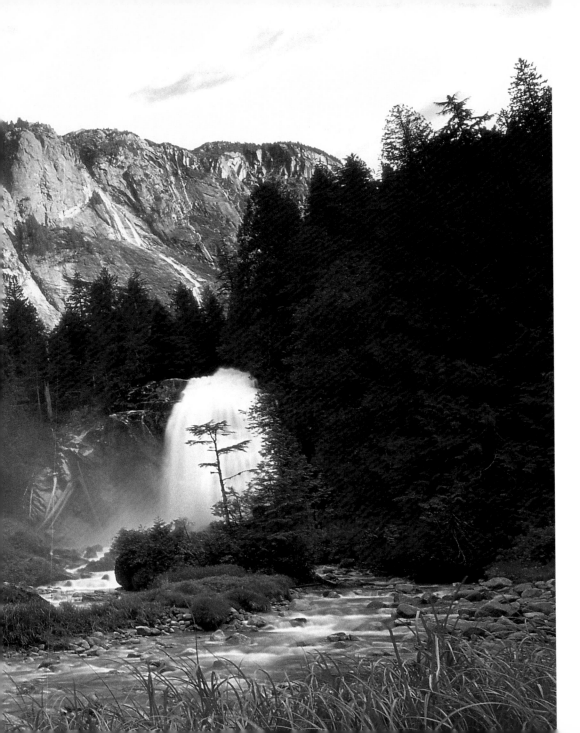

Chatterbox Falls is
one of more than 60
waterfalls that roar
down the cliffs at
Princess Louisa Inlet
each summer, when
the snow and glaciers
above are melting
most quickly.

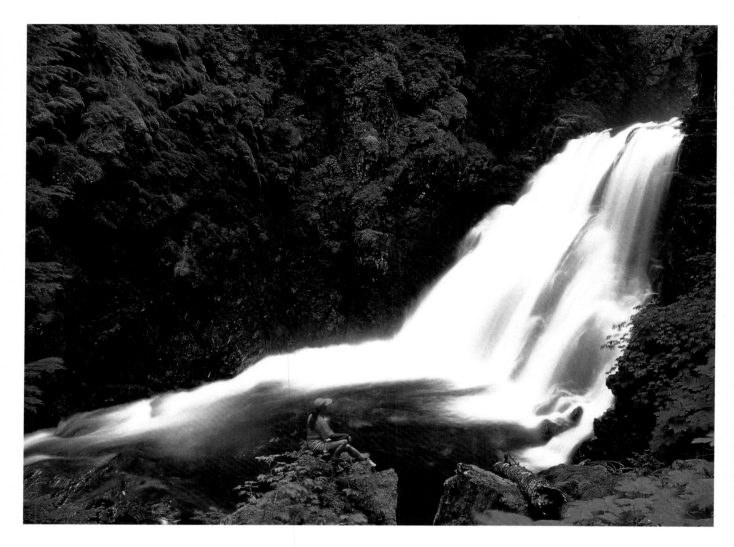

In the lush forest of the Bella Coola Valley, a hiker rests under the spray of a waterfall.

Weather-worn totems and fallen house timbers are all that remain of the once-thriving village of Ninstints, where smallpox killed most of the native population. Anthony Island Provincial Park now protects the poles, and the area has been declared a UNESCO World Heritage Site.

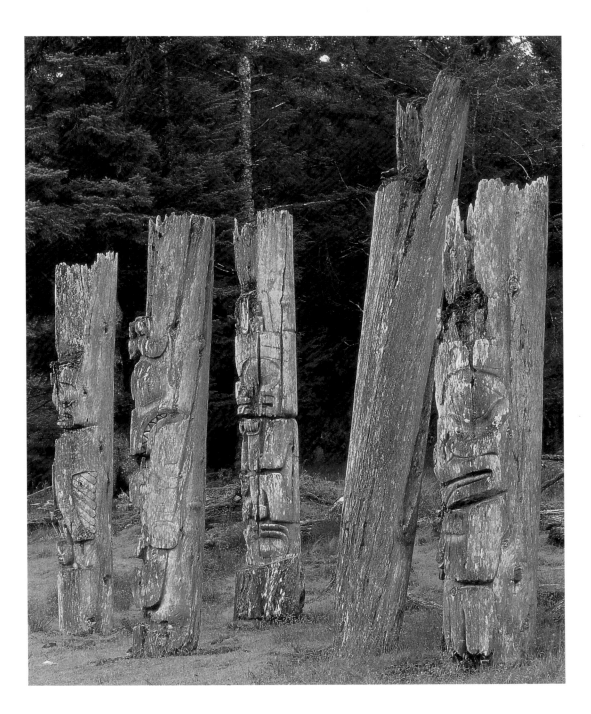

The Sea to Sky Highway winds north from Vancouver, skirting Howe Sound and Garibaldi Provincial Park. Built in the 1960s to allow skiers access to the resort destination of Whistler, the road now continues north to link the mountain towns of Pemberton and Lillooet and several backcountry parks.

FACING PAGE –
Campers enjoy the early-morning stillness of Garibaldi Lake. The campsites here are a four-hour hike from the nearest parking lot– those who make the climb have earned the view.

OVERLEAF –
One of B.C.'s most popular wilderness areas, Garibaldi Provincial Park is a haven for hikers, campers, and skiers.

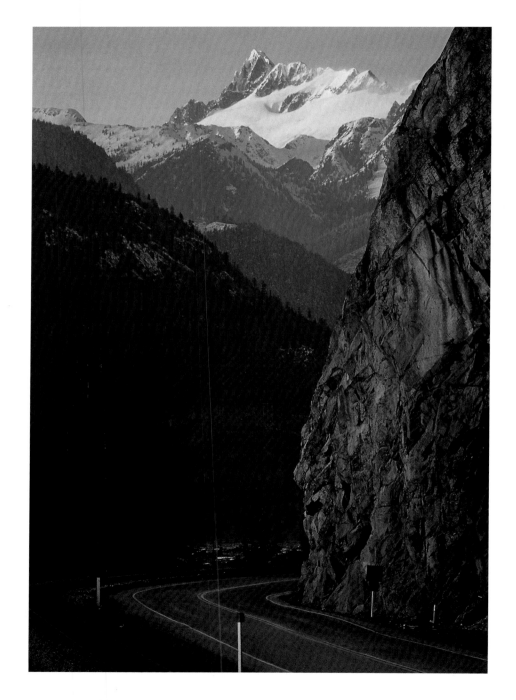

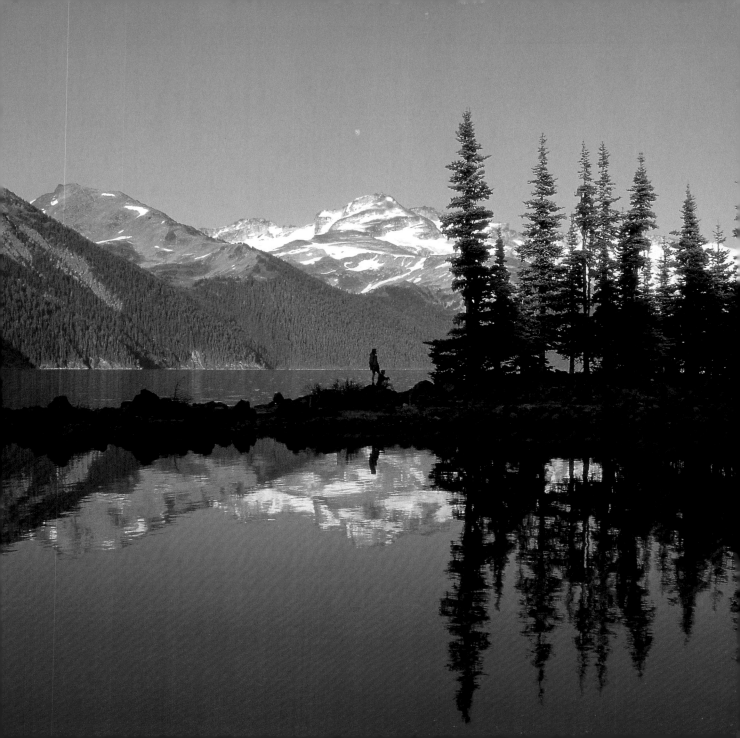

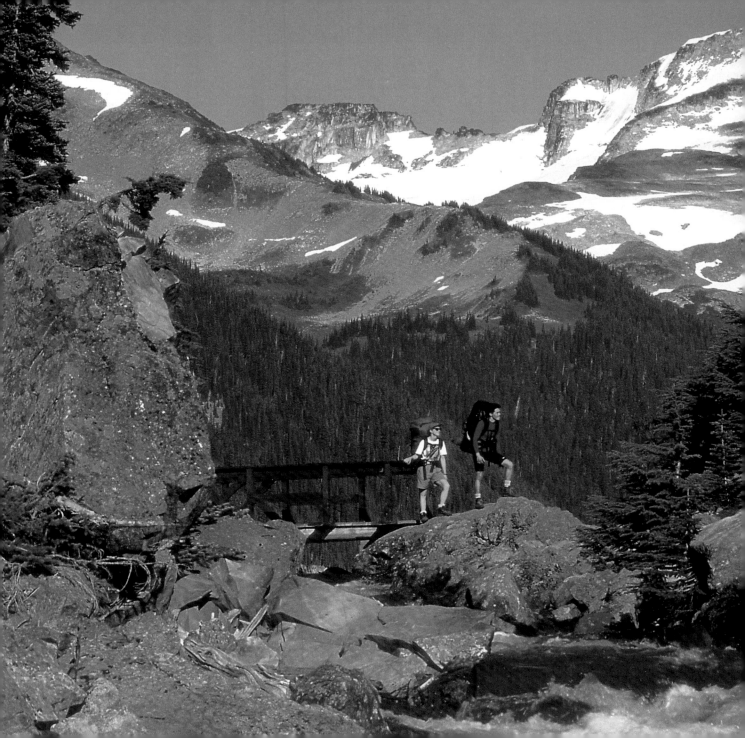

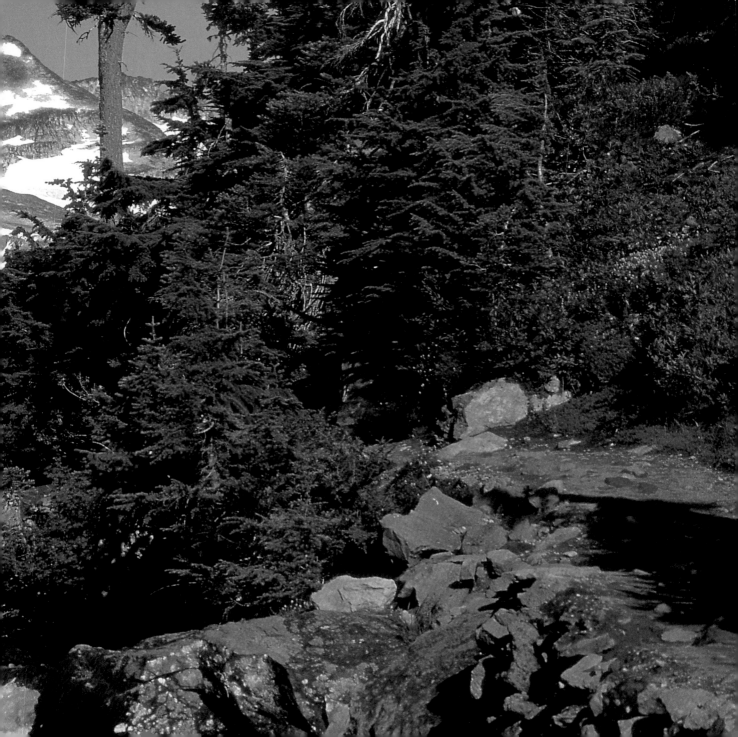

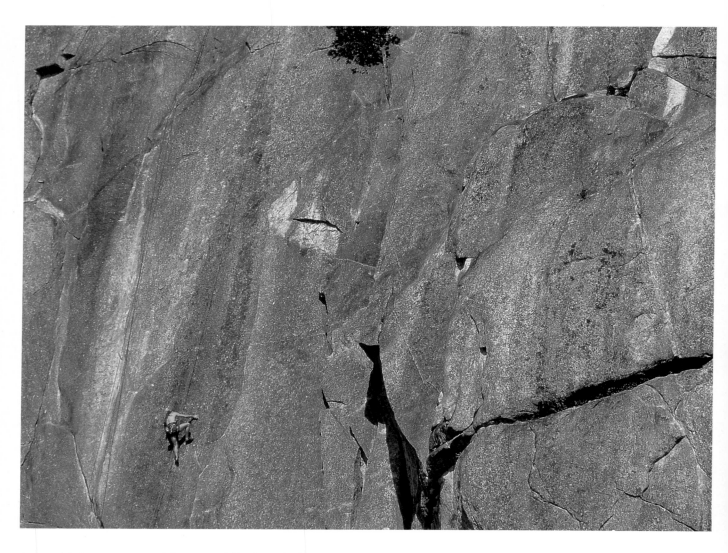

Squamish boasts some of the most difficult rock-climbing routes in Canada, and this climber has a long way to go.

A skier angles quickly through the powder on Mount Atwell, in Garibaldi Park.

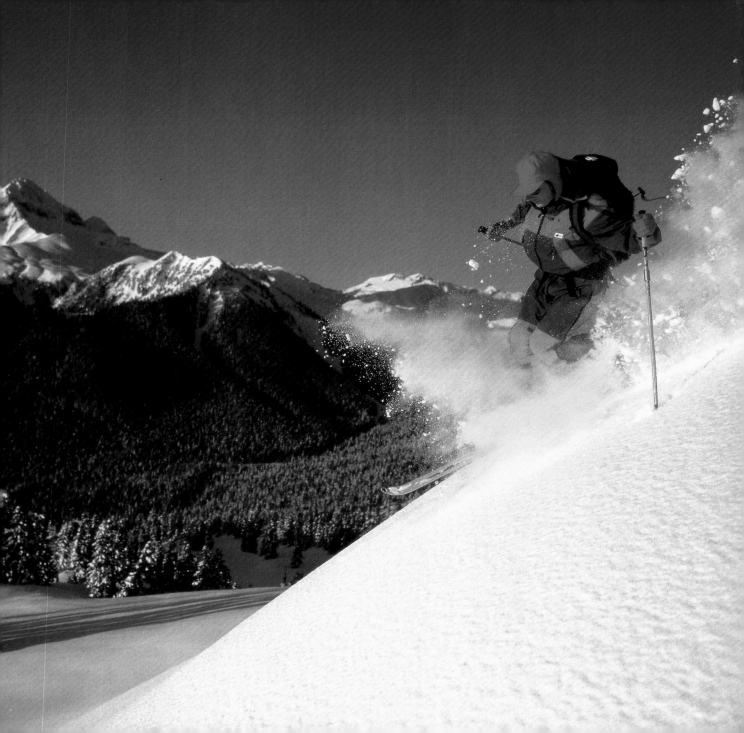

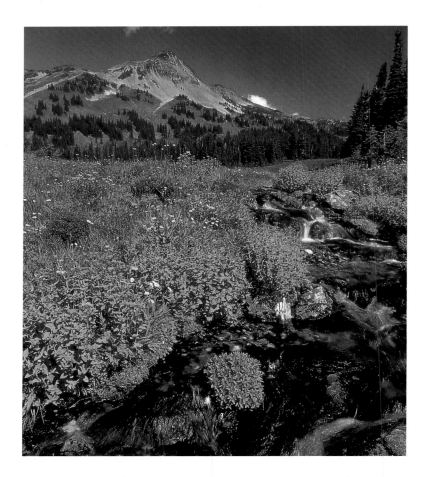

Near the centre of Garibaldi Provincial Park, 2315-metre Black Tusk rises above a wildflower-carpeted meadow. Climbers must carefully scale the loose rock of a narrow, 100-metre chimney to reach the peak.

The ski runs of Blackcomb Mountain rise above Whistler Village. Just north of Vancouver, this is one of the most popular ski resorts in North America.

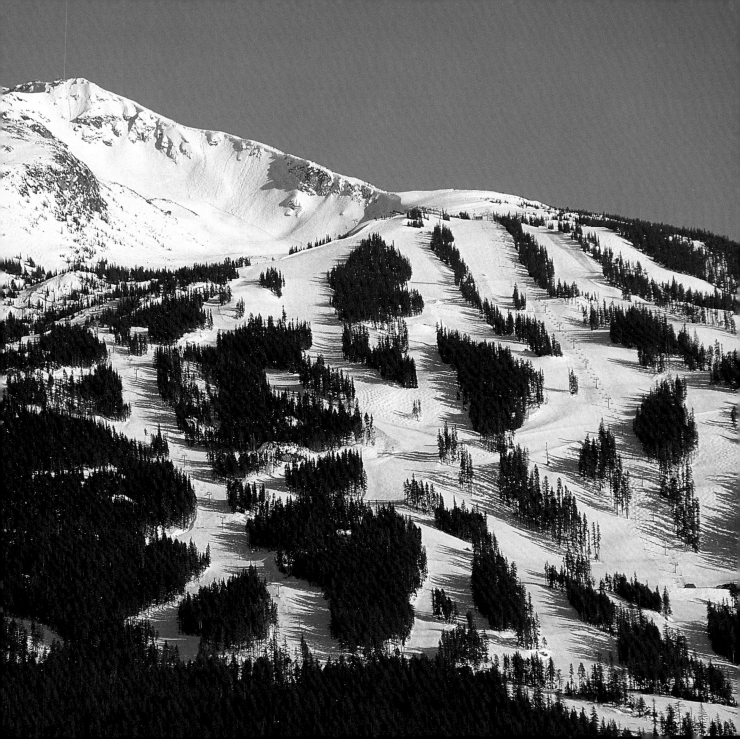

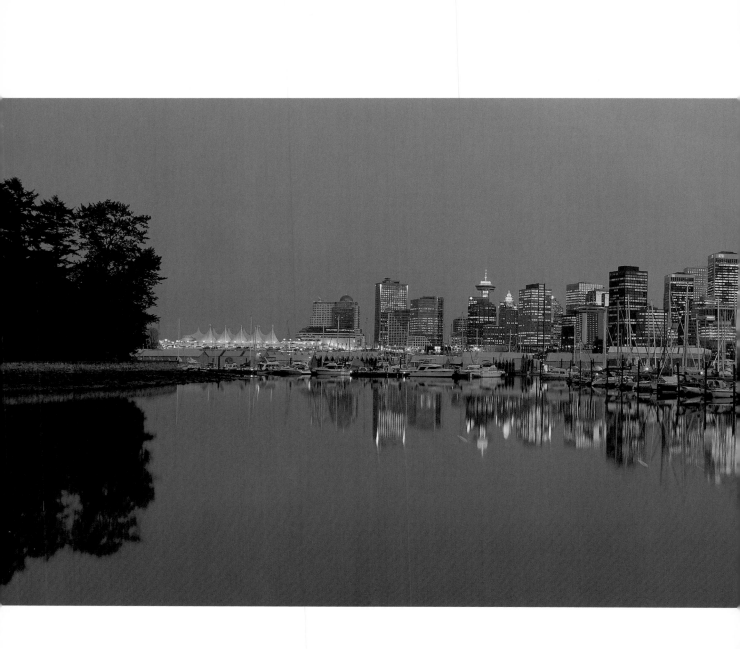

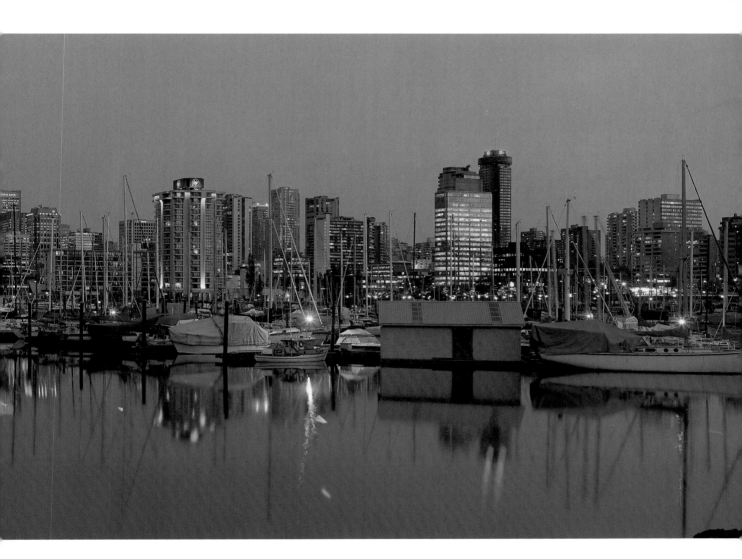

Canada's third–largest city, Vancouver is a stunning juxtaposition of modern highrises and natural beauty. Burrard Inlet forms the northern edge of downtown, and pleasure boats, cruise ships, and tankers stream through its waters.

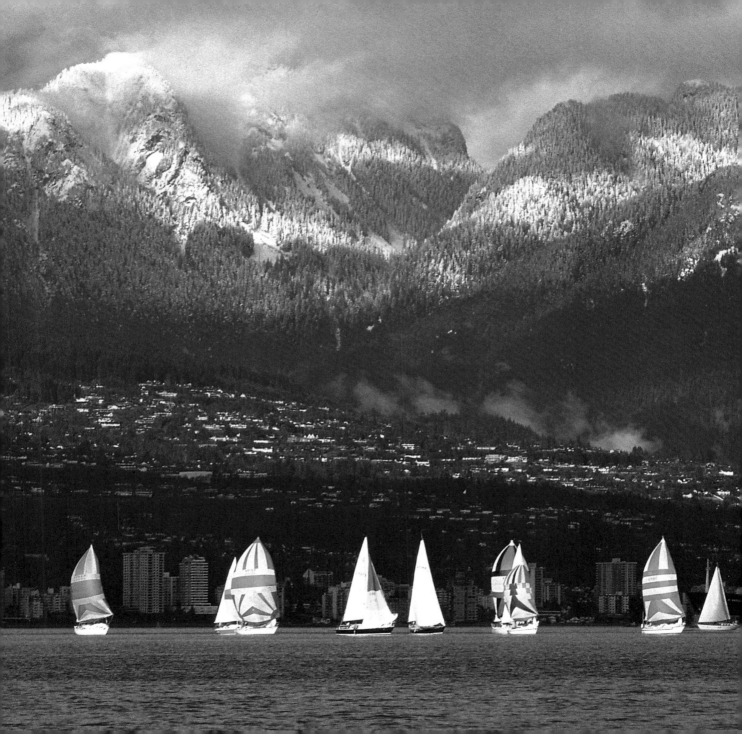

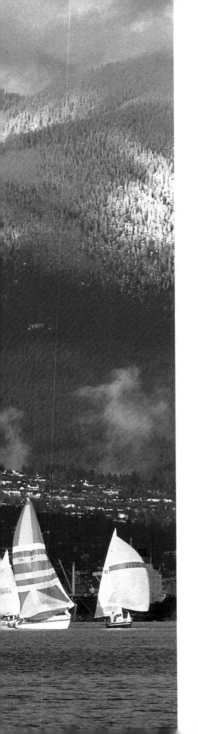

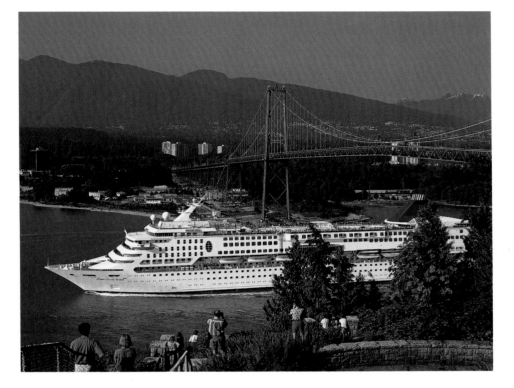

A cruise ship steams under the Lions Gate Bridge. Each year, Vancouver hosts more than 300 cruise ships and about one million passengers. Most are bound for Alaska.

Even in British Columbia's largest city, people have a passion for outdoor activities. Because of Vancouver's prime location on the Strait of Georgia, sailing is a popular pastime.

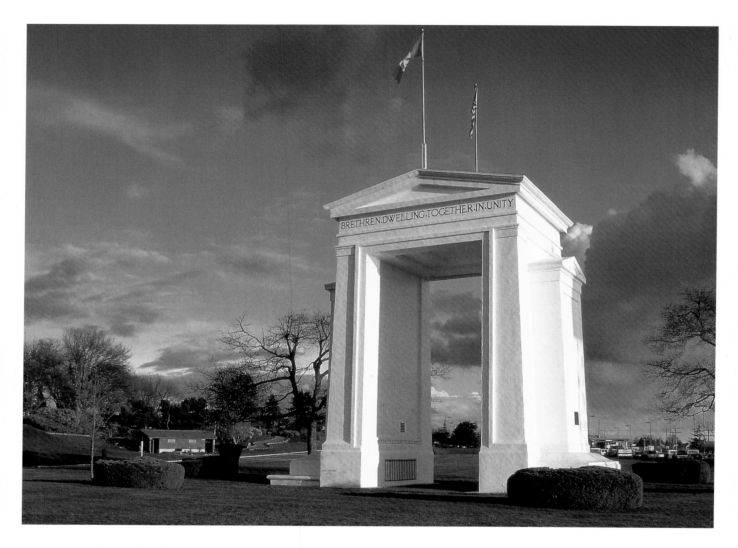

The Peace Arch was built by an American road builder in 1920 to commemorate peace between the United States and Canada. The arch stands on international land, with one pedestal in each country. The park surrounding the arch is jointly managed by British Columbia and Washington State.

Rich with the silt deposits of the Fraser River, the fertile Fraser Valley is a patchwork of farms and fields only an hour's drive from the bustle of Vancouver.

OVERLEAF –
The Coast Mountains rise above
one of the dykes in Pitt Meadows.

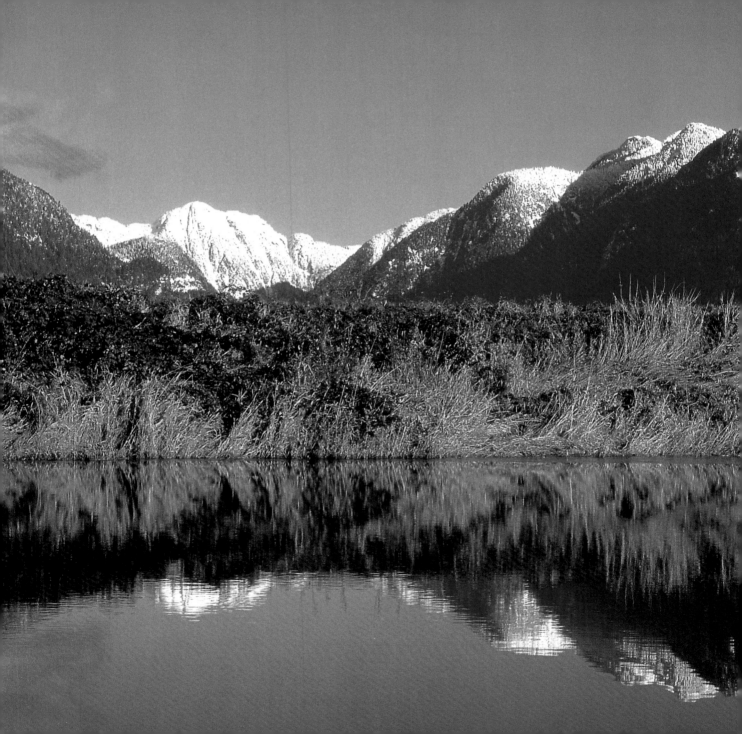

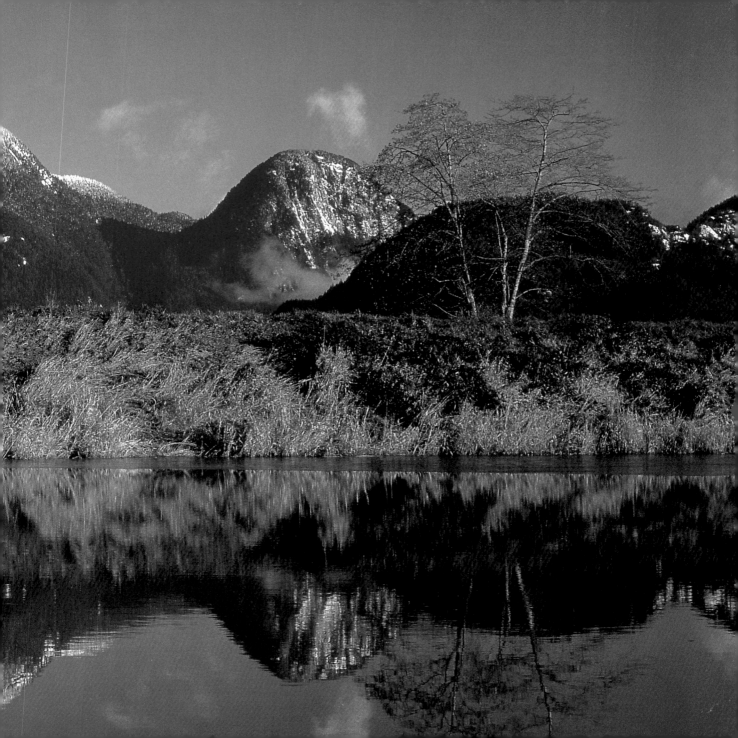

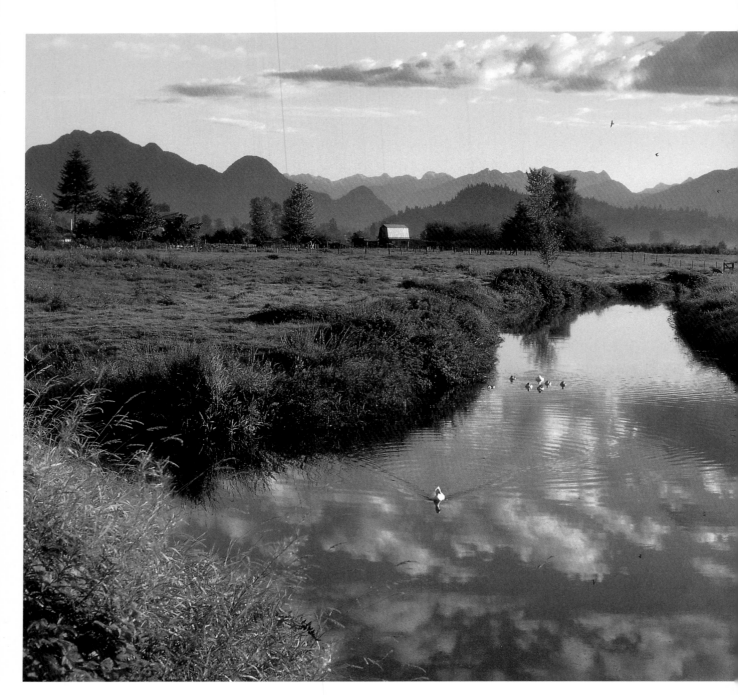

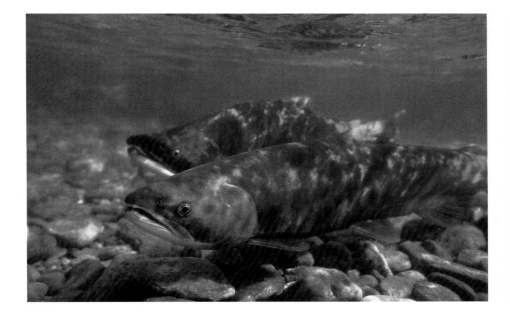

Swimming towards home, scarlet sockeye salmon head for their spawning grounds. One of the best places to see this migration is along the Adams River, near Shuswap Lake. Fry spend a year in the lake before retracing their parents' route to the Pacific.

Dykes and canals protect the farmland of the Fraser Valley, which supplies the province with much of its produce and berries.

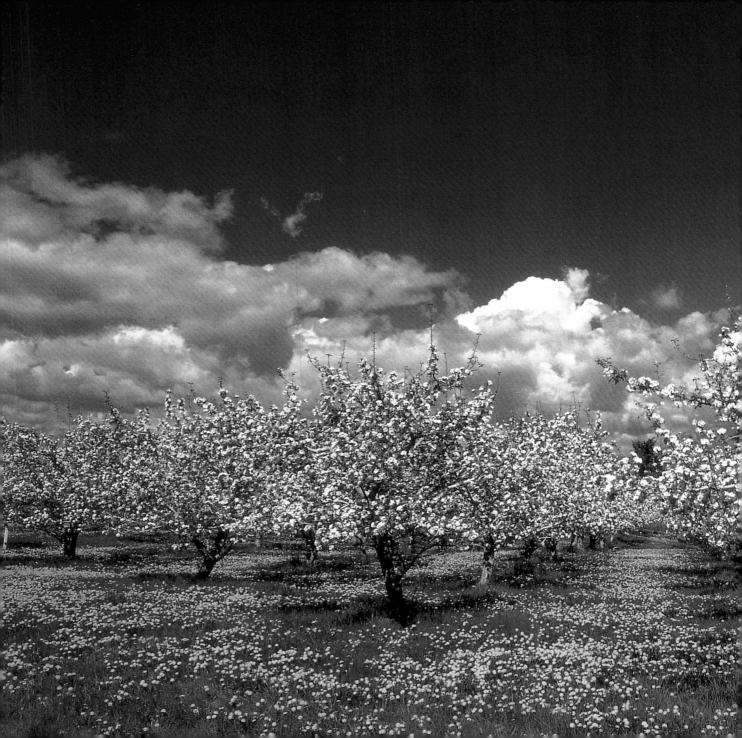

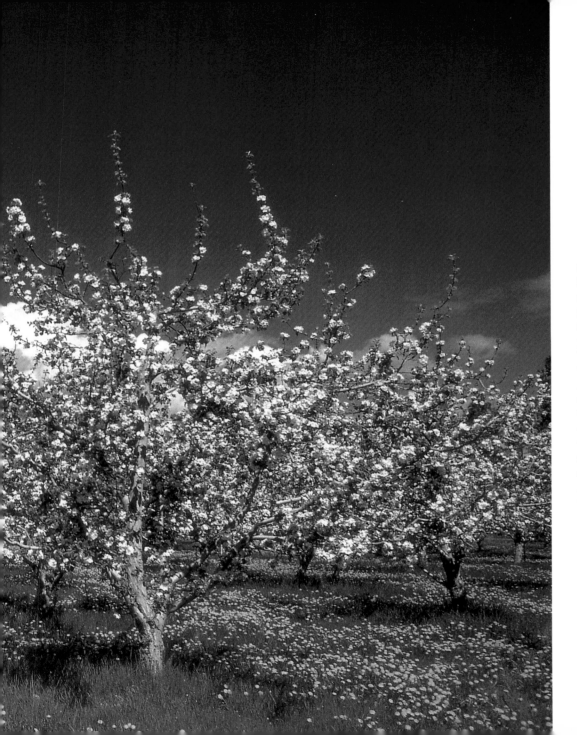

Okanagan orchards keep the province and the world supplied with apples, cherries, peaches, plums, and pears. There are 2000 fruit tree growers in B.C. Most live in the Okanagan, Similkameen, and Creston valleys. Fruit from these areas is sold in more than 30 countries and earns about $35 million a year in export sales.

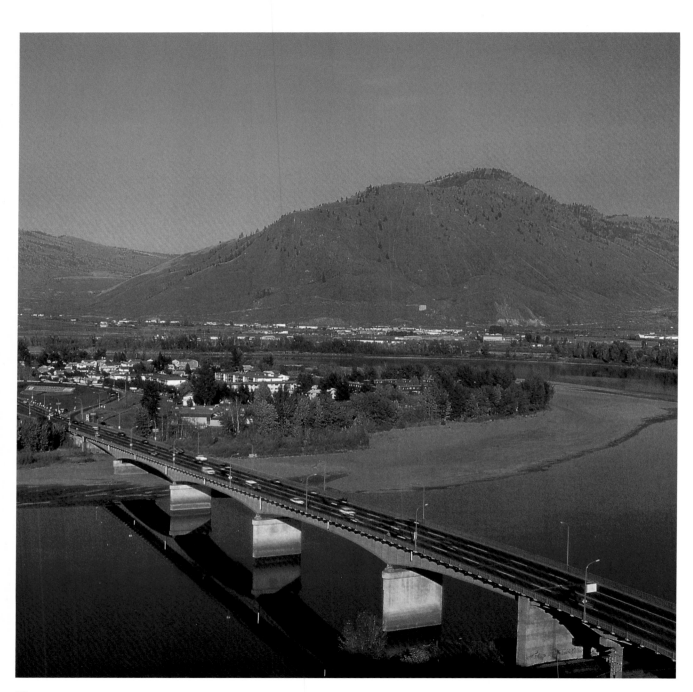

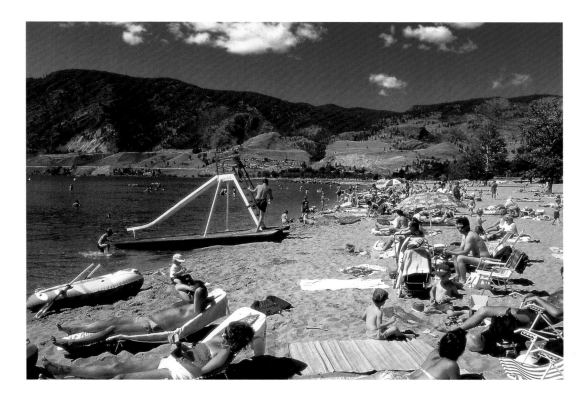

The Okanagan is British Columbia's hottest region, and these Skaha Lake swimmers and sunbathers obviously appreciate the sunshine.

Once a major fur-trading post, the city of Kamloops is now a ranching and industrial centre.

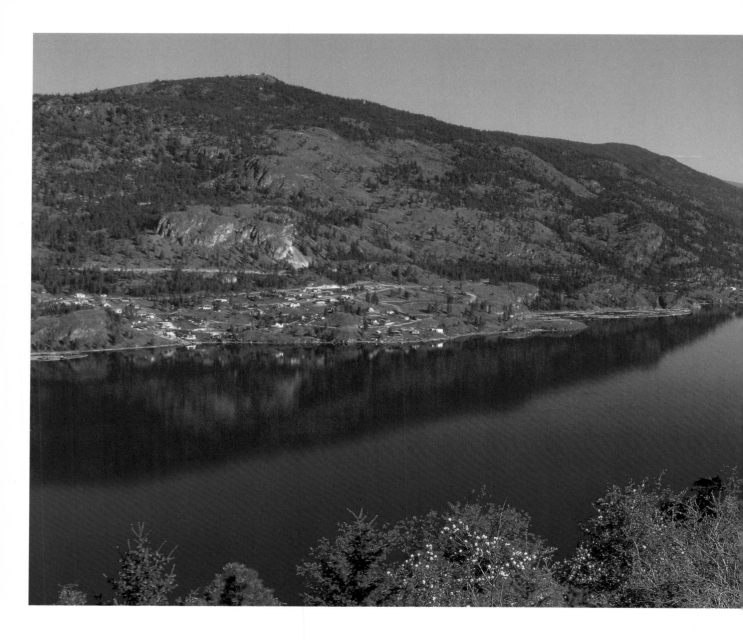

From Knox Mountain near Kelowna, Okanagan Lake looks peaceful, but it's a very popular place in summer. Even the legendary Ogopogo lake monster can't keep vacationers away from the warm waters and sandy beaches.

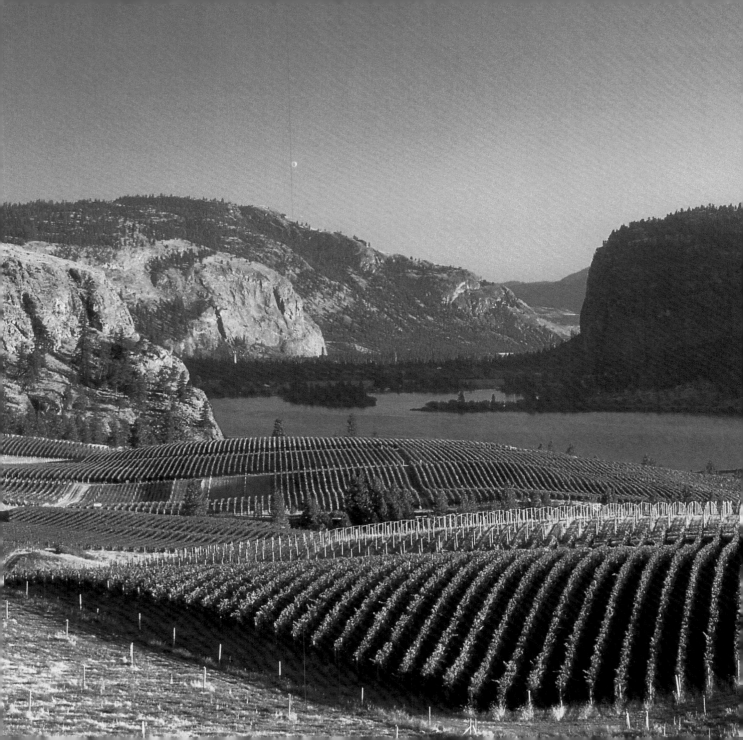

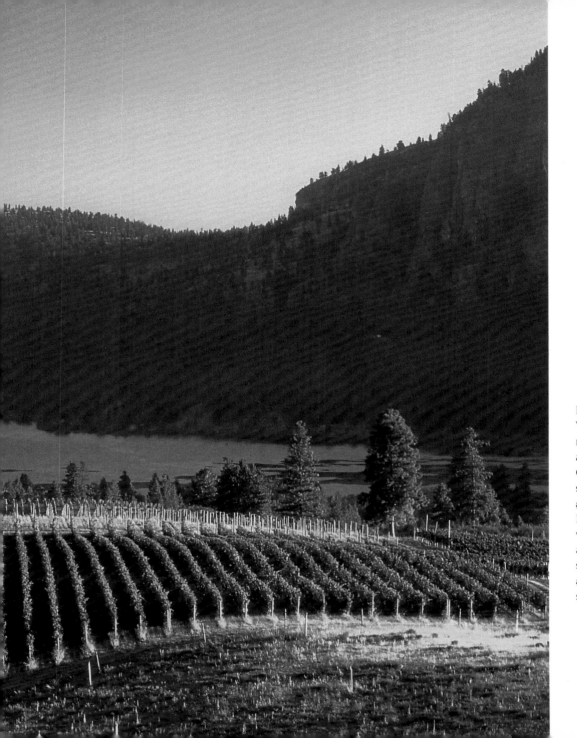

Blue Mountain Vineyard is one of many that takes advantage of the Okanagan's hot, dry summers. In the background lies Vaseux Lake, a bird and wildlife sanctuary that attracts trumpeter swans and Canada geese, among other species.

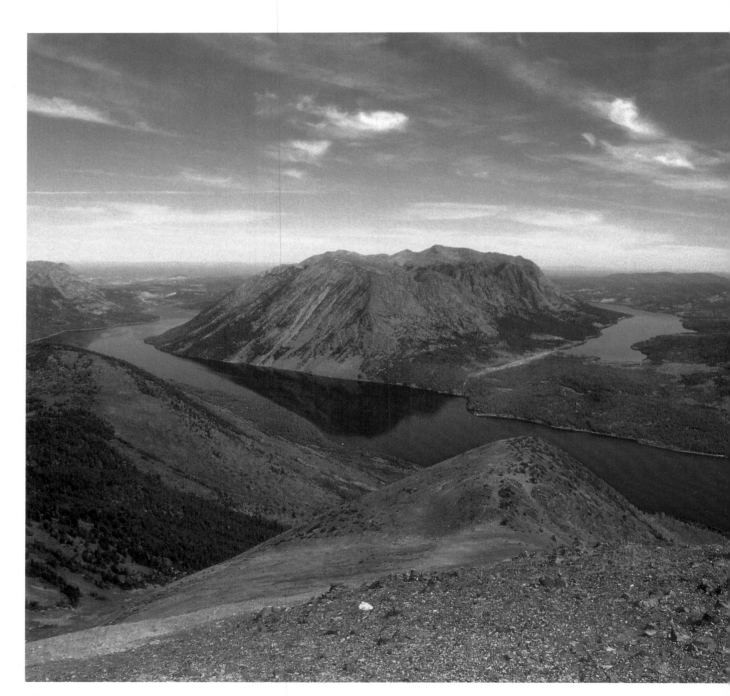

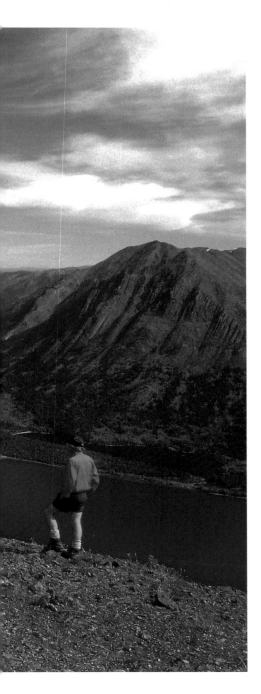

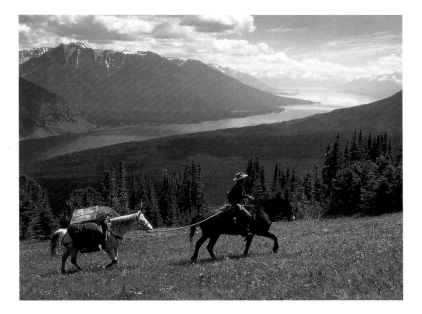

Ts'yl-os Provincial Park was created in 1994 through a partnership between the B.C. government and area First Nations. The combination of strong winds and low rainfall make the land unique. The park is known for interesting rock formations and rare plants, as well as its ample hiking and fishing opportunities.

From one of the highest peaks in the Coast Mountain range, a hiker looks down on Chilko and Tsuniah lakes. The area is a favourite with canoeists and anglers, but high winds and sudden storms make it necessary to stay alert.

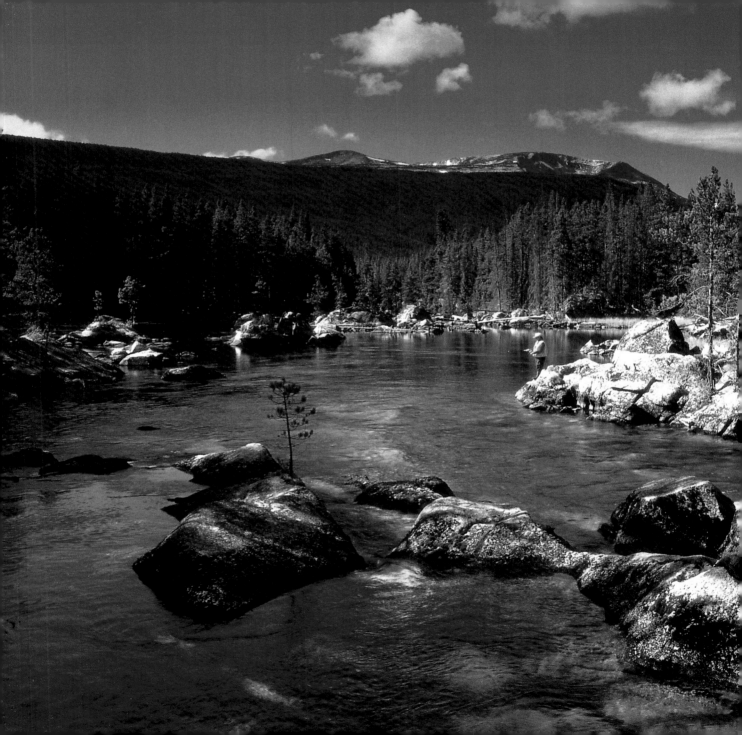

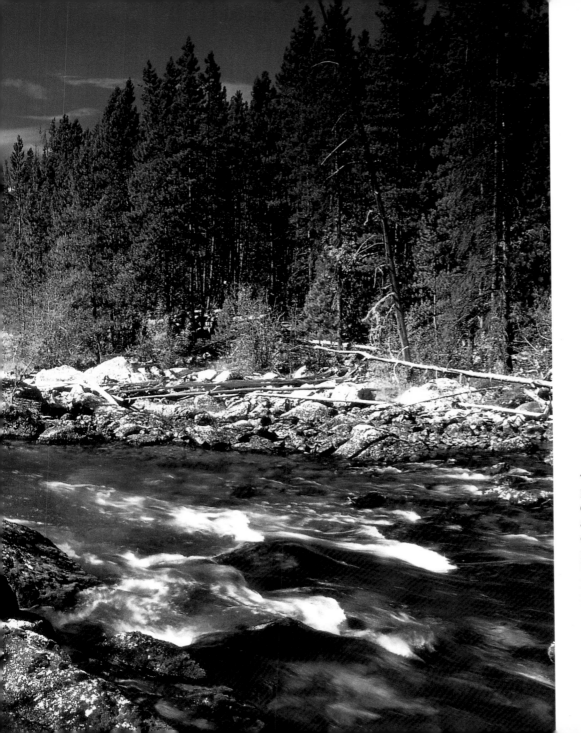

The area surrounding Nimpo Lake in the Chilcotin region is an angler's heaven. Not only are there many prime sites nearby, but float planes transport people to more remote fly-fishing locations.

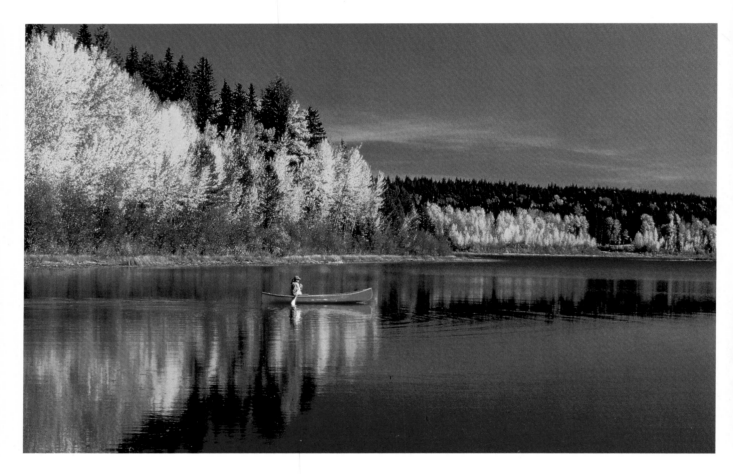

A canoeist enjoys a tranquil moment on Cariboo Lake.

Whitewater rafting trips through the Thompson River's rapids make the nearby town of Lytton a base for adventure seekers. The trips are said to be completely safe, but the names of the rapids–Jaws of Death and Devil's Kitchen–reveal the reactions of earlier, less well-equipped travellers.

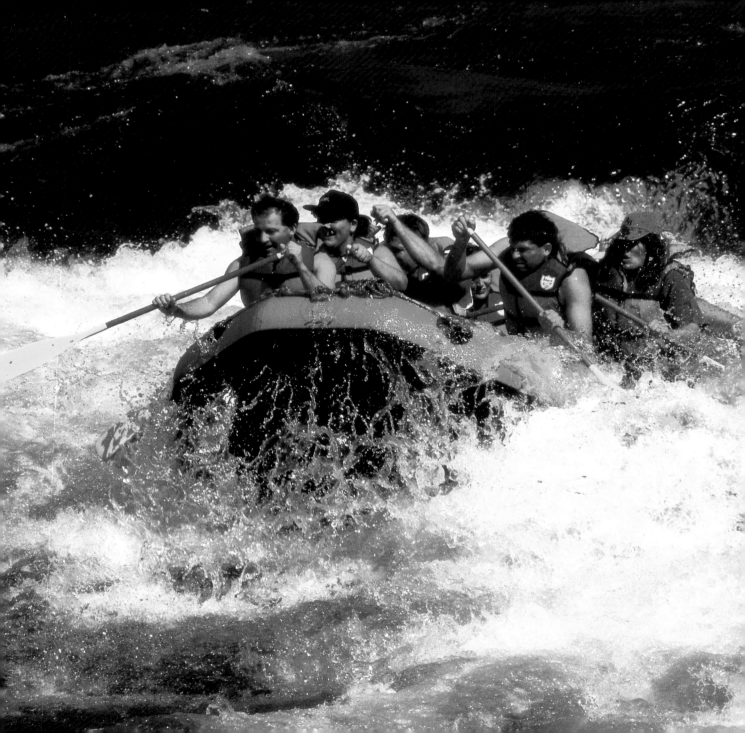

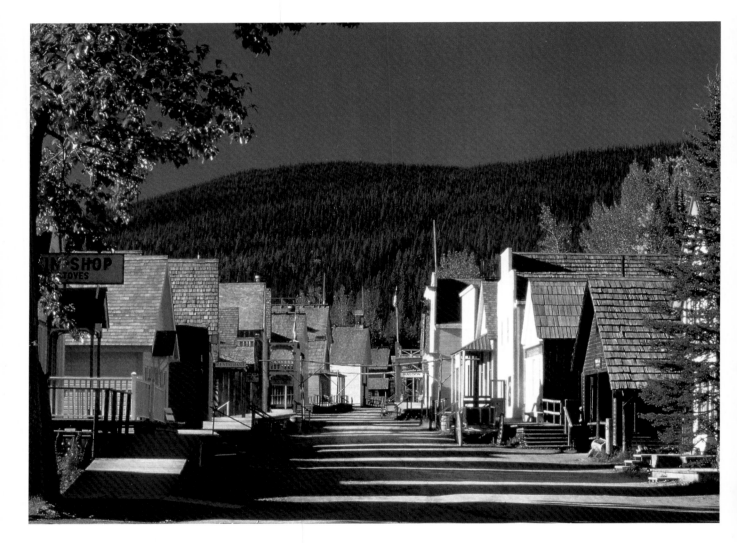

Barkerville was once a Cariboo gold rush boomtown.
Now the site is a provincial park where visitors can
tour restored buildings or pan for gold.

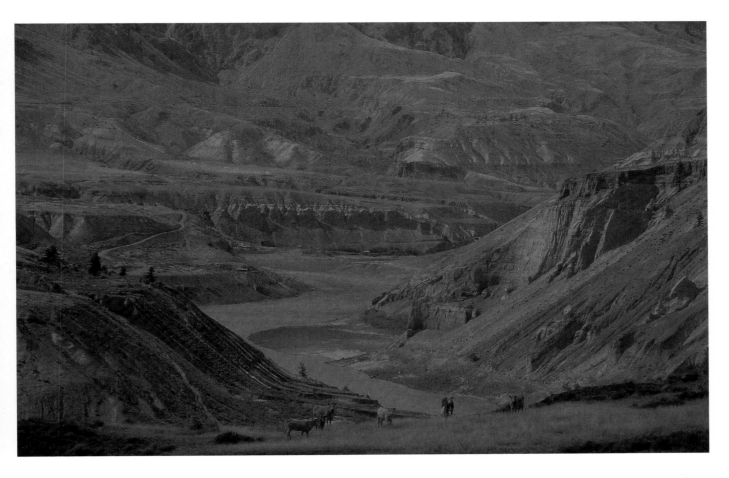

A large part of B.C.'s rangeland is in the Cariboo region, where enormous cattle ranches stretch among the hills.

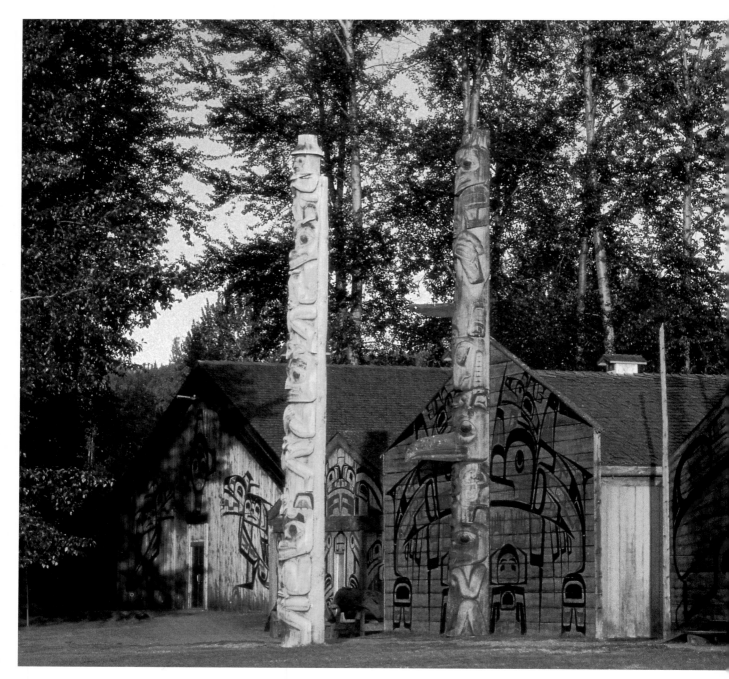

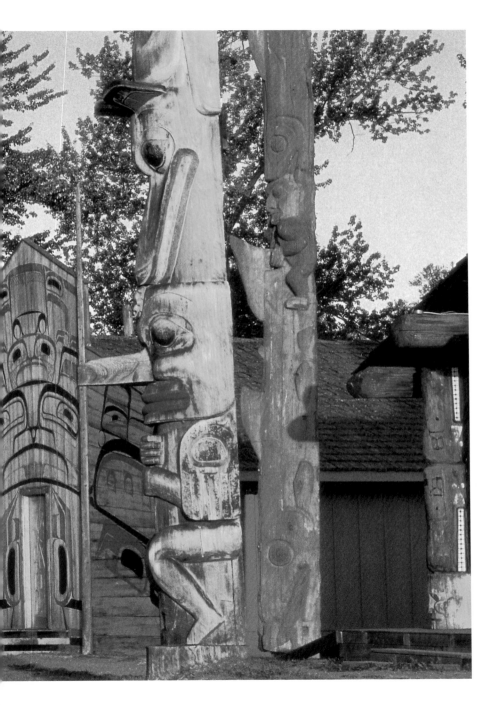

A carving school and historical site at the 'Ksan Village in Hazelton ensure that First Nations culture remains strong. First Nations people have lived in the area for more than 7000 years.

Fall colours transform an aspen forest in
the Peace River Valley.

Rows of canola stretch to the horizon
in the Peace River region.

OVERLEAF —
Near Dease Lake in northern B.C., Mount Edziza
Provincial Park offers a unique volcanic landscape,
complete with obsidian. This hard, glass-like rock was
once used by area First Nations to make tools. The
land is isolated and rugged; an experienced hiker
needs about two weeks to cross the park.

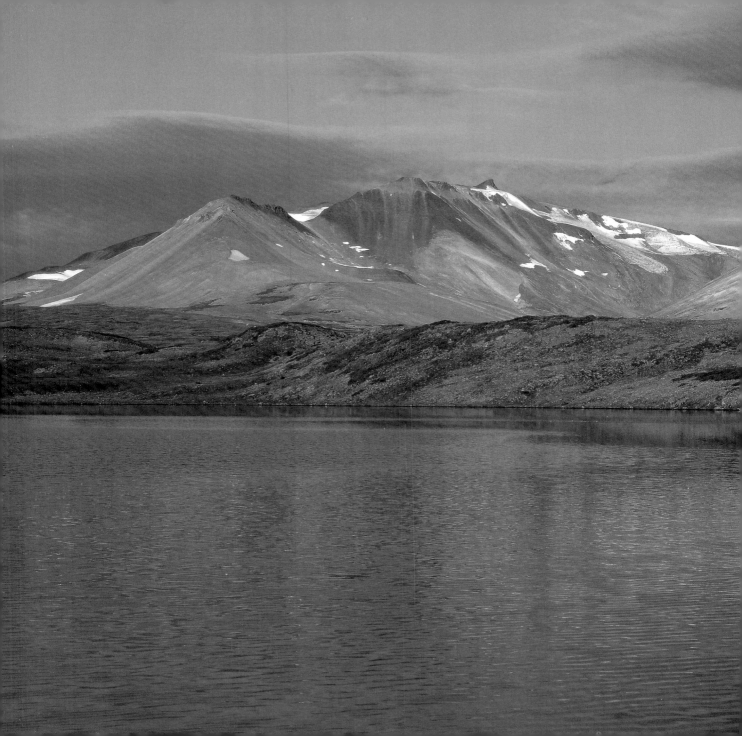

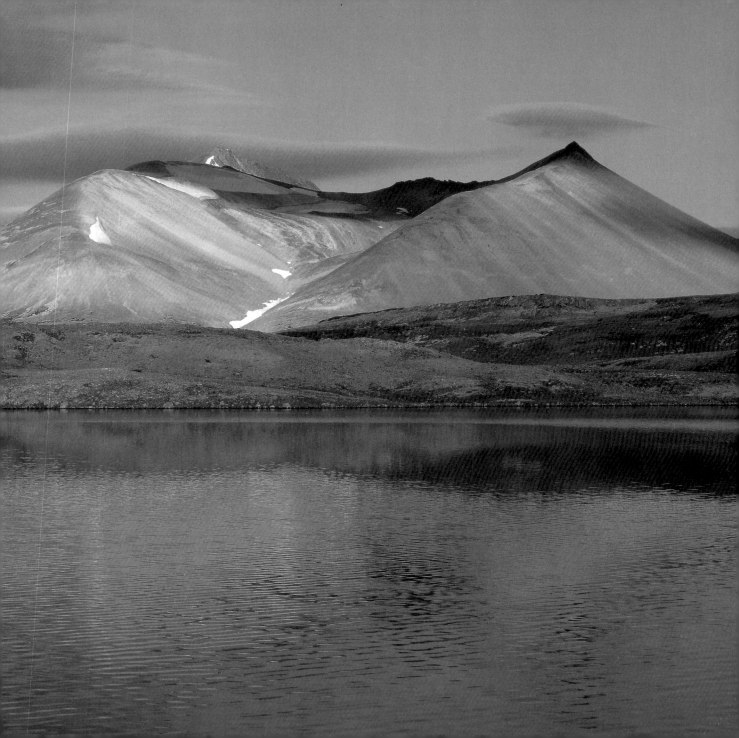

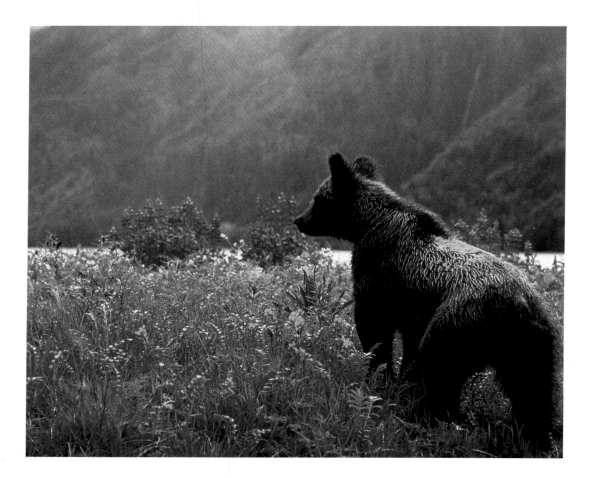

Khutzeymateen is a native word meaning "a confined place for salmon and bears." The area is a protected grizzly sanctuary and thousands of bears gather each fall to feast on the migrating salmon.

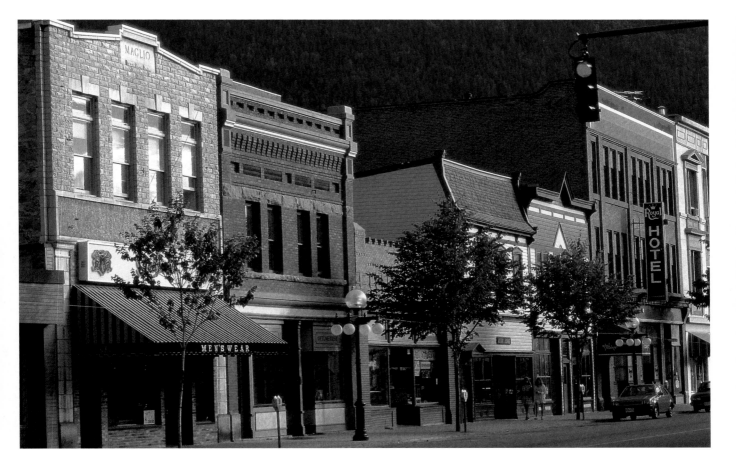

Artisans' shops and art galleries line Nelson's Baker Street, in the West Kootenays. Many of the historic store-fronts have recently been restored.

Visitors to historic Fort Steele can enjoy live vaudeville shows at the Wild Horse Theatre and buy stick candy at the General Store. The town was once a gateway to the Wild Horse Creek gold rush and was named after a famous gold rush law enforcer, North West Mounted Police Superintendent Sam Steele.

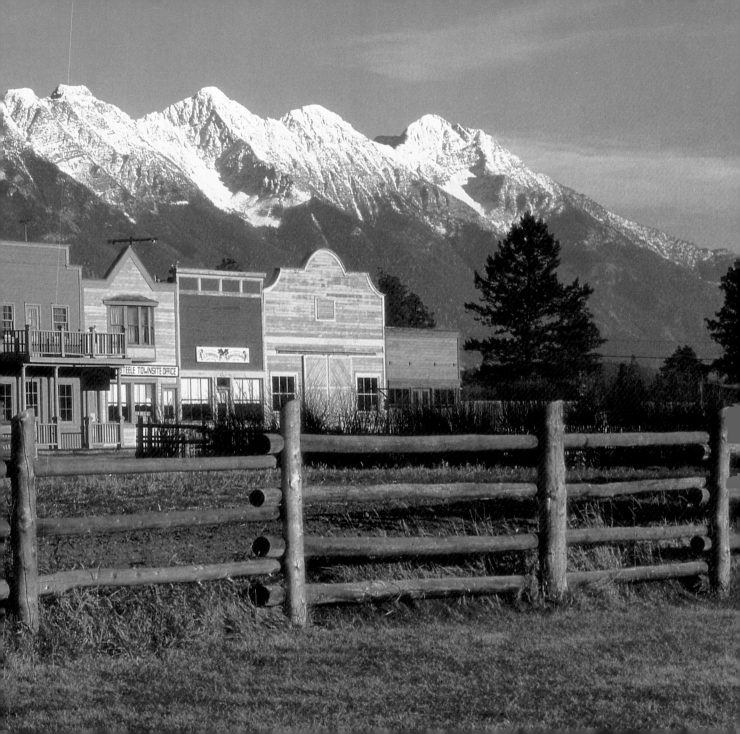

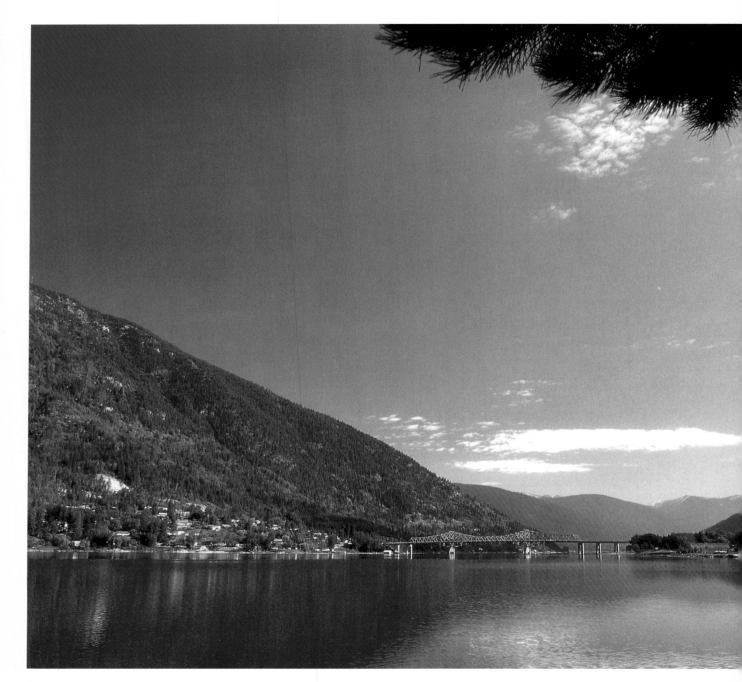

The Creston Valley flats were once flooded each year by the Kootenay River. Dykes built between the 1890s and 1930s controlled the flooding and opened the rich land to alfalfa, corn, potato, and canola fields. This is the largest agricultural area in the Kootenay region.

The city of Nelson lies along the protected west arm of Kootenay Lake. Because water from the many mountain creeks moves quickly through the lake and towards the Columbia River, the water is especially clean and cold. Boaters enjoy the lake year-round, but swimmers don't venture in until July.

OVERLEAF —
Bugaboo Glacier Park includes the largest icefields in the Purcell Mountain Range. Many of the mountains here tower to more than 3000 metres (9840 feet).

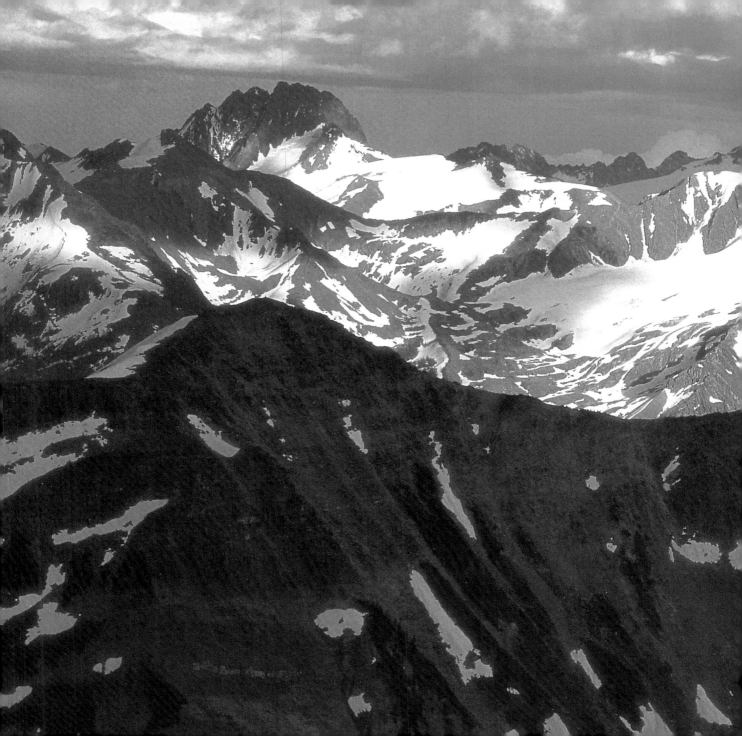

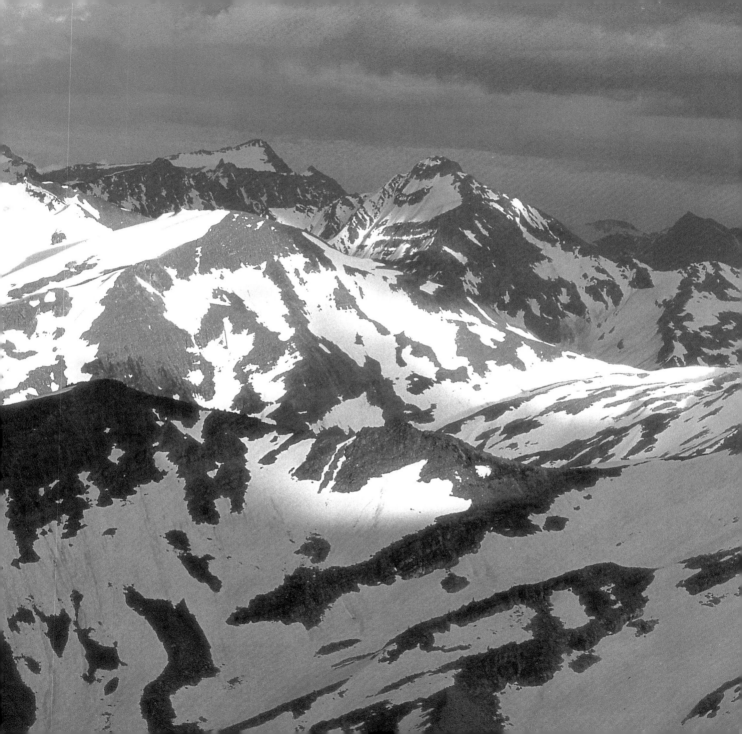

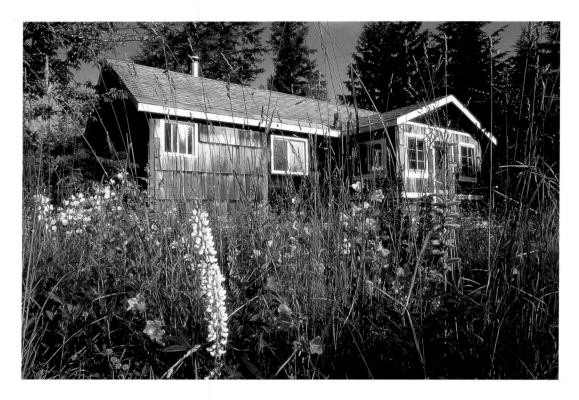

During World War II, 13,000 Japanese
Canadians were wrongly suspected of
threatening national security and forced
from their homes along the Pacific.
Hundreds of people were interned in
New Denver, in small, uninsulated
shacks like this one.

Wildflowers cover a meadow in Mount
Revelstoke National Park, at the foot of
the Rockies.

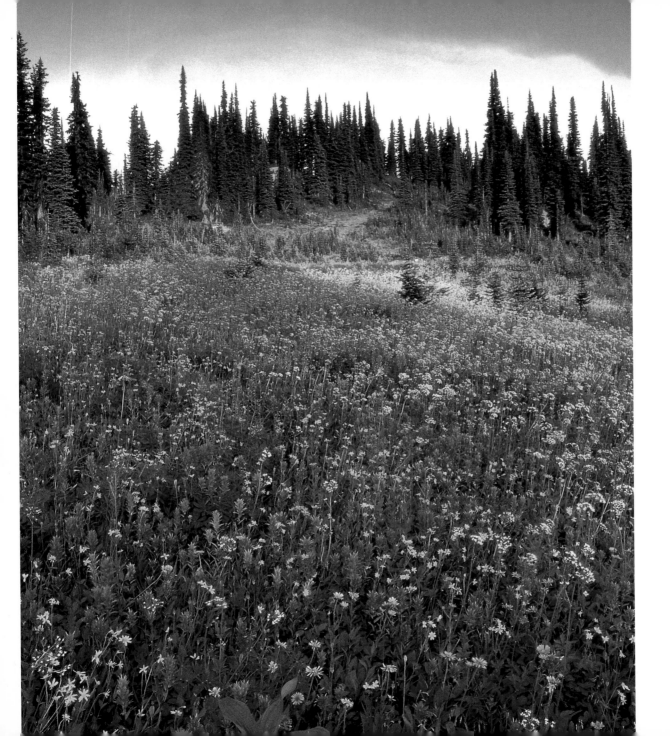

Mount Robson is the highest peak in the Canadian Rockies, and its summit is almost always obscured by cloud. Canada's third largest river, the Fraser, originates here.

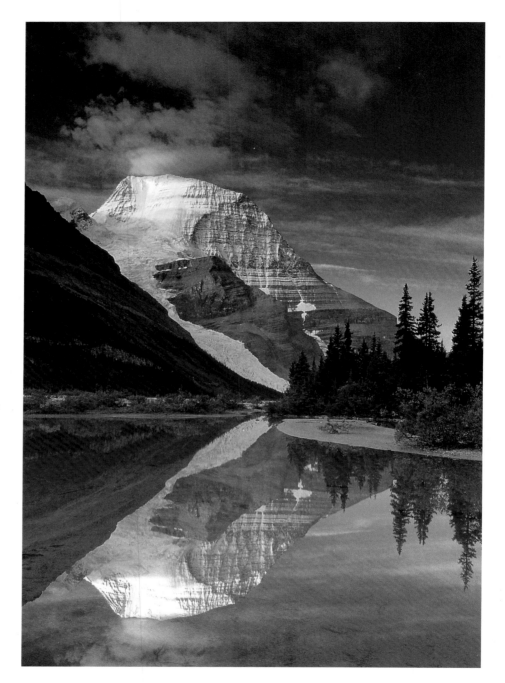

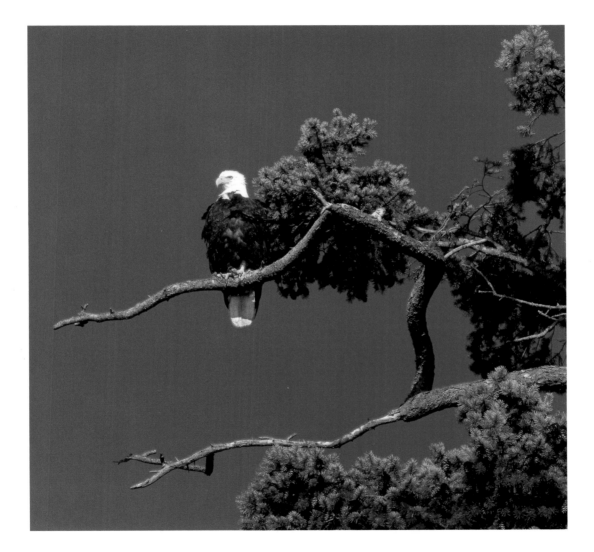

Though most common along the coast, bald eagles can also be spotted circling above the large lakes of the Interior. More than 25 percent of the world's bald eagles live in B.C.

More than 30 hiking trails begin at Lake O'Hara.

Facing Page –
At the peak of the spring run-off, 255 cubic metres a second pour over Wapta Falls into the Kicking Horse River.

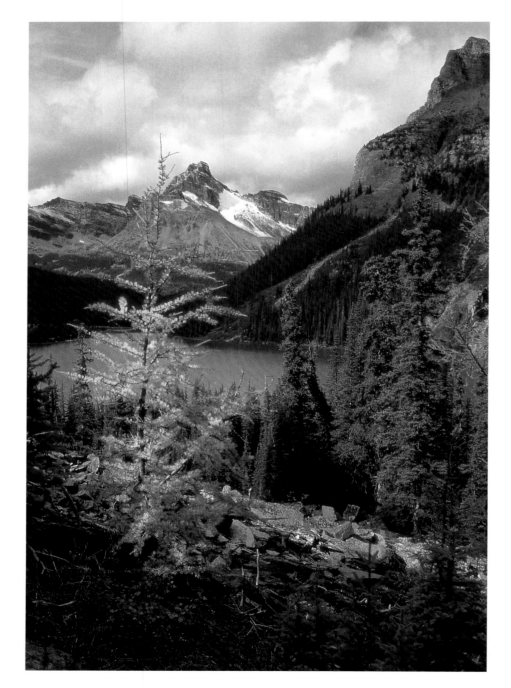

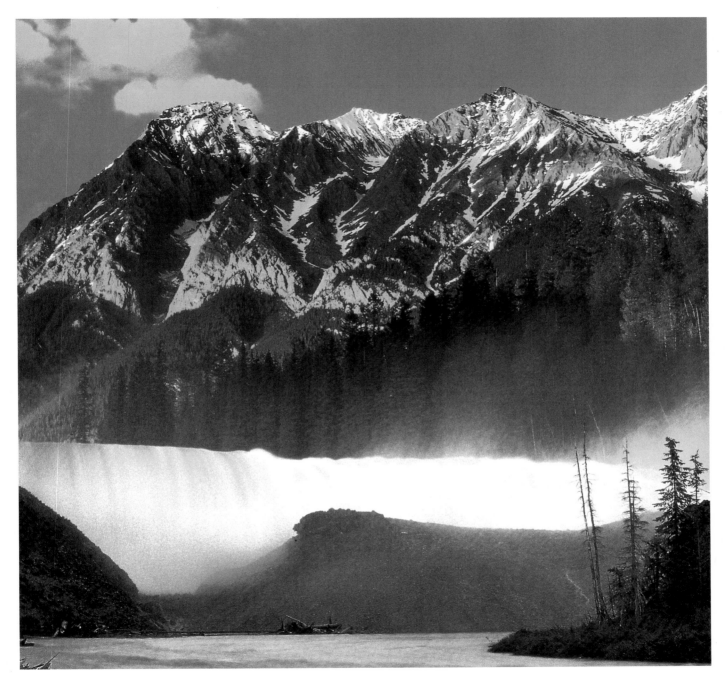

The icy, glacier-fed waters of Emerald Lake are a popular stop along the Trans-Canada Highway.

Facing Page –
Glaciers grind tiny particles of silt into the ice. When the ice melts, the particles remain suspended, turning the waters of mountain lakes, such as McArthur Lake in Yoho National Park, an aquamarine blue.

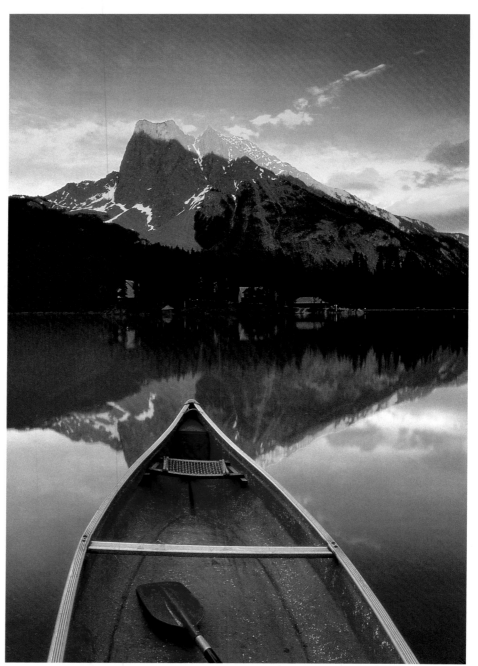

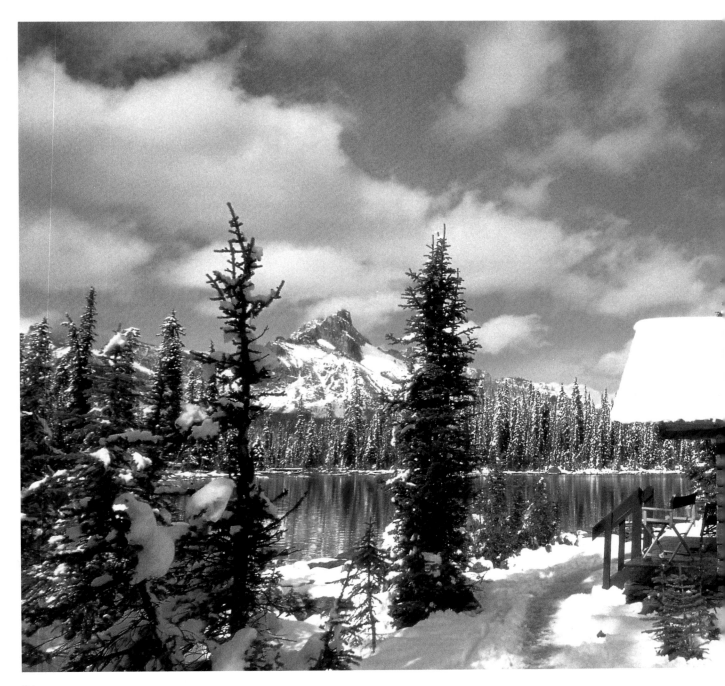

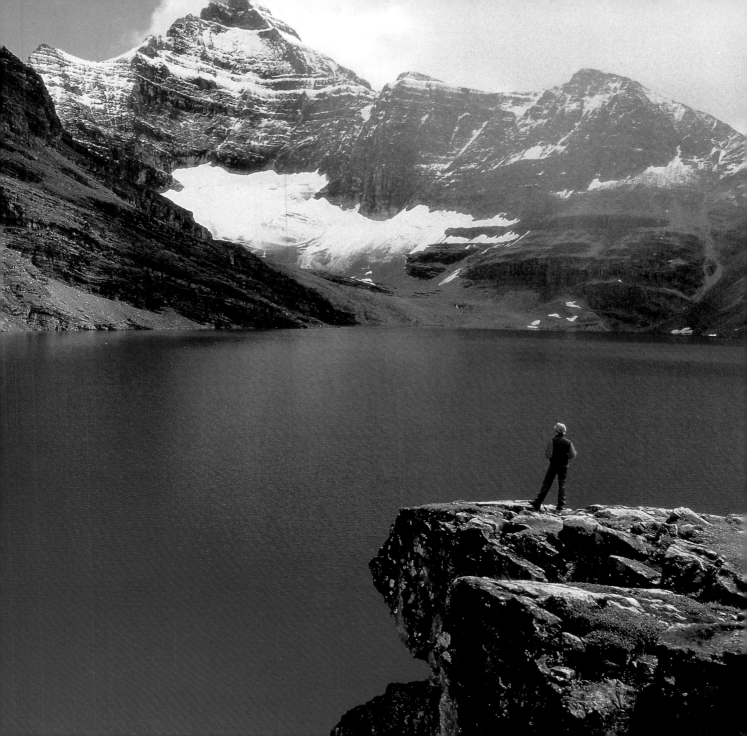

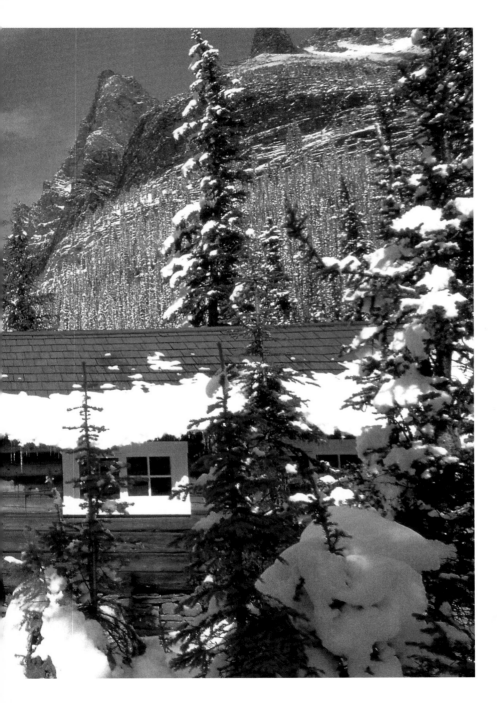

Snow surrounds Lake O'Hara in Yoho National Park. Though the log cabin at the shore is definitely more popular in summer, a few cross-country skiers appreciate the winter shelter.

Photo Credits

CONTENTS

Introduction *4*

INTRODUCTION

In France everyday dessert at home tends to be cheese and fresh fruit. In the land of *boulangeries* and *pâtisseries* with tantalizing shop windows, few French home cooks try to compete with the professionals. They tend to buy rather than bake their daily bread. For a very grand party, particularly if they have shown off with the rest of the meal and spent hours in the kitchen, they might serve an exquisite concoction, put together by the best *pâtissier* in town. This is not done covertly in any way. The French are well-trained in spotting – and appraising – the work of masters of their craft. As every mouthful of the (horribly expensive) store-bought wonder is savored, the hostess or host is asked who the *pâtissier* is and praised by the guests for her or his choice.

Yet for more *intime* special occasions, a get together of old friends, a significant family gathering or birthday party, the French turn to favorite desserts and family recipes perfected over the generations. Every serious home cook has such a repertoire. Recipes are jealously guarded and willingly prepared. In the home kitchen, fruit, bitter chocolate and cream are turned into unpretentious mouth-watering tarts and gâteaux for appreciative but critical audiences. If the *profiteroles* or the chocolate cake aren't quite up to the expected standard, someone around the table is bound to suddenly remember a grandmother, family friend or aunt who was so good at making desserts . . .

Il faut ce qu'il faut . . . You need what it takes. There is no stinting on ingredients for a special *dessert*. The butter that can be so liberally used is unsalted (as it tends to be in French cooking in general). Cream is *crème fraîche*, with a stable texture and a ripe,

slightly tart flavor. Superfine sugar is a staple, often discretely flavored with a pod of vanilla. Eggs are present when called for in the recipe but as part of a whole rather than as the main ingredient of the sweet.

Fruit is the most commonly used base, with desserts reflecting the produce of the season and of the region.

In the elaborate *tartes* of Normandy and the plainer cakes of Brittany, apples steal the show, as do plums and cherries to the north and east of the country, while candied fruit and nuts play a greater part further south.

Unlike humble home-grown fruit, that other versatile dessert ingredient, chocolate, has always been regarded as a luxurious food. French children develop a taste for dark chocolate early in life with their *goûter,* a mid-afternoon snack which often consists of a small bar of chocolate and a *tartine* of bread. When they are "in the money" they spend their francs on *pains au chocolat*, croissant pastry stuffed with black chocolate before baking. Crafty *pâtissiers* bring out trays of the irresistible puffy golden rectangles from their ovens at 4:30 or 5:30 in the afternoon in time for the end of the local schoolday . . . Good quality bittersweet chocolate with a high percentage of cocoa is easy to find on the shelves of French supermarkets. More expensive, but well worth buying, are handmade ultra fine *tablettes*, bars crafted in the kitchens of individual *chocolatiers*, *confiseurs* and *pâtissiers.* Their potent flavor and rich chocolatey taste transform hot sauces and cake coatings – I always slip one or two in my suitcase before leaving France.

FRUITS ET RECETTES A BASE DE FRUITS

FRUIT AND FRUIT-BASED RECIPES

FROMAGES ET FRUITS

CHEESE AND FRUIT

France is a land of orchards and over 300 different cheeses, so, not surprisingly, fruit and cheese is the standard French dessert. Good cheeses are expensive and the elaborate *plateaux de fromages* are reserved for special occasions. For their everyday fix, cheese lovers prefer one well-made cheese to an inferior selection of cheeses.

A classic cheese board will consist of at least 3 different cheeses. The choice varies a great deal from region to region – the French are passionate defenders of their local produce, particularly when it comes to cheese and wine. In Paris you will probably get a ripe round of Camembert or a wedge of Brie, both soft cow's milk cheeses with a marked faintly sweet smell, Camembert's being more persistent than Brie's. Next to it will be a blue cheese, perhaps Roquefort, with its strong salty taste, or the somewhat less powerful Fourme d'Ambert, which is still richly complex. The third cheese will probably be made from goat's milk, a *chèvre,* dusted with a fine coating of grey ash, finely tuned between fresh and pungent, creamy and dry-textured. Quality varies enormously and cheese lovers enter into long discussions with their suppliers before buying their *fromages.*

Cheese is normally eaten first. We often broke the rule at home and mixed the cheese and fruit courses – particularly in my grandparents' house which had a large orchard and predictable gluts of often unappealing fruit – the beautiful specimens were quietly vandalized by the family, adults and children alike, before they had a chance to reach the table. Once you removed the

damaged parts, the over-ripe segments, the craters left by birds or worms, what remained of the fruit tasted surprisingly good. Bruised pears and white peaches burst with juicy flavor, wrinkled grapes with fragrant sweetness, wizened rennet apples had a tight refreshing texture. These fruit pieces (you needed several of them to make a helping) were perfect with cheese. I still like eating Camembert or Gruyère with wedges of crisp apple, very creamy cow's cheeses with a few red grapes, unripened mild goat's cheese with white grapes, blue cheese with slivers of pear. On a recent visit to the Basque country, I tasted ewe's milk cheese with cherry preserve, a favorite local combination. Neatly presented, cheese and fruit make a wonderful party platter – a *grand plateau* that is a very impressive last course for a mid-week dinner party.

FRAISES A LA CREME ET AU FROMAGE BLANC

MARINATED STRAWBERRIES WITH CREAM

Serves 4

2 pints ripe hulled strawberries
1 cup orange juice
juice of 1½ limes
1 tbsp each finely grated unwaxed orange and lime zest
1½ tbsp liquid flower honey
1½ tbsp Cointreau or other orange liqueur
⅔ cup sour or light cream
½ cup fromage blanc or light cream cheese
confectioner's sugar
a few strips each of unwaxed orange and lime zest, blanched if you like
a few small mint leaves (optional)

Dampen a pastry brush and clean the strawberries. Cut lengthways into 4 slices and distribute between 4 wide bowls.

In a cup, combine the orange and lime juice, grated zest, honey, and orange liqueur. Pour over the strawberries and refrigerate for at least 1 hour.

Just before serving, in a bowl, whisk together the cream and fromage blanc. Whisk in 1 tablespoon of cold water if the mixture is too solid. Sweeten to taste with confectioner's sugar. Pipe or swirl over the strawberries, put the reserved fruit on top and scatter over the strips of zest, and, if you like, a few mint leaves.

FRUITS EN PAPILLOTE

FRUIT SKEWERS IN FOIL PARCELS

Serves 4

mixed ripe but firm fruit: apple, banana, nectarine or apricot, grapes, clementine, pear, segments of fresh pineapple, etc.
2 tbsp soft unsalted butter

For the marinade:

1 tbsp lemon juice
2 tsp orange juice
2 tbsp caster sugar
3 tbsp light rum or kirsch (optional, use extra fruit juice if you prefer)

To serve:

crème fraîche or thick plain yogurt

Chocoholics may like to add the marinade juices to hot Dark Chocolate Sauce (page 28) and pour this over the fruit skewers.

★ Cut the fruit into attractive bite-sized segments. Put these in a bowl. Mix the marinade ingredients together in a cup, pour over the fruit and toss lightly. Leave to macerate for about 30 minutes.

Heat the oven to 450°F. Thread the fruit very loosely on 12 skewers. Reserve the marinade juices.

Cut 4 pieces of thick foil each large enough to wrap loosely around 3 fruit skewers. Put 3 skewers on each piece of foil and dot with butter. Bring the edges together to make a loose parcel. Bake for 10 minutes.

To serve, open up the hot parcels and drizzle over the marinade juices. Eat as soon as possible, with crème fraîche or thick plain yogurt.

PECHES AU VIN BLANC

PEACHES IN WHITE WINE

Serves 4

4 ripe peaches
confectioner's sugar, to taste
2 cups chilled dry white wine
1 tbsp unsalted butter
2 tbsp slivered blanched
almonds
2 tsp superfine sugar
almond macaroons, to serve

Take a ripe peach. Chop it, put it in a glass and cover with wine . . . This fruit-and-wine concoction traditionally prepared at the table by my seniors when I was growing up was crude but effective. The following version is more elaborate but still only takes minutes to prepare. Dry Muscat is a nice wine to use, as is Chardonnay.

★ Bring a saucepan of water, large enough to hold the peaches side by side, to a boil. Add the peaches and return to a boil over moderate heat. Reduce the heat a little and leave to simmer for 3 to 5 minutes.

Lift out the peaches with a slotted spoon. Leave until cool enough to handle, then peel off the skins. Cut each peach in half and remove the pit.

Put each peach back together again and stand in a glass. Using a small strainer, dredge them with a little confectioner's sugar. Cover with wine and refrigerate while you eat the rest of the meal – or longer if more convenient.

At the last minute, put the butter in a small frying pan and melt it over moderate heat. Stir in the almonds, sprinkle over the sugar and sauté for 1 to 2 minutes, until golden. Scatter the mixture over the peaches. Serve with almond macaroons.

COUPE FRAICHE DE FRUITS

SUMMER FRUIT PLATTER

One of my life's greatest little luxuries is having fruit prepared for me. Since there are few volunteers for the job of Peeler–Slicer Extraordinaire, I often prepare a large platter for myself and others to enjoy. Even the most reluctant lazy fruit eater is happy to dive into a beautiful selection of morsel-sized freshly prepared *fruits de la saison*. Use your imagination and an appetizing mixture of whatever fruit is available and to your liking.

★ Bring a saucepan of water to a boil. Add the peach and nectarine, return to a boil over moderate heat. Remove from the heat. Lift the fruit from the pan with a slotted spoon, leave to cool for a minute, then peel the skins.

Peel the pear and apple. Cut the larger fruit into neat wedges. Arrange all the fruit as attractively as possible on a large glass platter or in a bowl.

Make a light syrup: in a small saucepan bring ½ cup water to a boil with the lemon and orange zest, the sugar, and wine. Reduce the heat and simmer for 5 minutes. Leave to cool, then drizzle the syrup over the salad. Refrigerate for at least 1 hour, or until ready to serve.

At the last minute, sprinkle over the lemon juice, then dredge with confectioner's sugar. If you like, serve with thick plain yogurt or Crème Chantilly (page 25).

Serves 4 to 6

1 ripe peach
1 ripe nectarine
1 ripe pear
1 small apple
2 soft apricots or
yellow plums
2 heaped tbsp small ripe
strawberries
2 heaped tbsp raspberries or
pitted sweet cherries
1 heaped tbsp red currants

For the syrup:

several strips of unwaxed
lemon and orange zest
3 heaped tbsp superfine
sugar
5 tbsp rosé or red wine
2 tbsp lemon juice
confectioner's sugar for
dredging

To serve (optional):

thick plain yogurt or Crème
Chantilly (page 25)

POIRES AU VIN

PEARS IN RED WINE

Serves 4

2½ cups red wine
l to 2 tbsp superfine sugar
1 tsp each finely grated
unwaxed lemon and
orange zest
pinch each of ground
cinnamon and nutmeg
4 ripe firm pears, peeled
2 tbsp lemon juice
2 tbsp orange juice

An old French favorite, this adult fall dessert is simple but needs to be prepared with care. Use pears that are ripe but still firm. Try to peel them smoothly, without applying pressure and cutting ridges into the flesh – a pointed vegetable peeler (preferably not a swivel action model) is the best piece of equipment to use. Work lightly, holding the peeler almost parallel with the pear. The next pitfall to look out for is the syrup, which has a tendency to reduce and darken in moments if not closely watched.

★ Mix the wine, sugar, lemon and orange zest, cinnamon, and nutmeg in a saucepan large enough to hold the pears standing side by side. Bring to a simmer over moderate heat and cook for a few minutes, then carefully stand the pears, side by side, in the pan. Top off with a little boiling water – the pears should be half immersed in liquid.

Return to a simmer, reduce the heat a little, and simmer for about 15 minutes, until the pears are just tender but not soft. During cooking, baste a few times with the simmering wine.

Using a slotted spoon, lift the pears from the liquid. Stand upright in a dish or individual dessert bowls. Leave to cool.

Turn up the heat, add half the lemon and orange juice to the wine and bring to a boil. Leave to simmer, stirring occasionally, until the liquid has reduced by about half and becomes a little syrupy.

Leave to cool, then stir in the rest of the lemon and orange juice. Taste the syrup and adjust the sweetness and flavorings. Spoon over the pears and leave until cold, then refrigerate for at least 1 hour. Serve chilled.

BANANES FLAMBEES A L'ANTILLAISE

PAN-FRIED BANANAS

Serves 4

*3 tbsp unsalted butter
4 ripe but firm peeled bananas
¼ cup superfine sugar
½ cup orange juice
5 tbsp rum or brandy, more if preferred
1 lime, cut lengthways into 4 long wedges, to serve*

From the French West Indies, this is a self-indulgent dessert. The mother of my best friend at school in Paris used to make wonderful *bananes flambées* oozing with buttery caramelized juices. I broke my first ever diet as a teenager (*hélas*, the first of many) over a plate of Madame Kermanchahi's bananas. Should anyone query giving a rum-laced dessert to an adolescent, let me add that alcohol evaporates at boiling point and during flaming. All that remains is the flavor and, of course, the calories.

★ Heat the butter in a frying pan large enough to hold the bananas comfortably side by side. Add the bananas and sauté for 3 minutes over moderate heat. Turn over and continue cooking until golden, reducing the heat a little if the bananas are browning too fast.

Sprinkle over the sugar, add the orange juice, and cook until bubbling. Reduce the heat a little and add half the rum or brandy. Simmer for 2 to 3 minutes, stirring and basting the bananas with the thick juices.

Using a metal ladle, warm the remaining rum or brandy. Put the bananas and pan juices (scrape well) in a heated serving dish. Drizzle over the warm rum or brandy. Standing well back and using a long match, flame the bananas – preferably at the table. Serve at once, with wedges of lime.

POMMES POELEES SUR BRIOCHE

PAN-FRIED APPLES ON BRIOCHE SLICES

Another fry-up of a quick dessert which makes a good quick substitute for Tarte Tatin.

★ Sprinkle the apples with lemon juice. Melt half the butter over low heat in a large frying pan. Evenly sprinkle half the sugar over the melted butter.

Spread the apple wedges out in the pan. Sauté for 3 to 4 minutes over moderate heat, shaking the pan a few times but without stirring the apples.

Meanwhile, toast the brioche. Spread lightly with butter, then dredge with confectioner's sugar.

Now carefully turn over the apples and reduce the heat a little. Cut the rest of the butter into slivers and scatter these in the pan. Sprinkle with the remaining sugar, the cinnamon, and raisins. Cook for a further 3 to 5 minutes until the apples are golden and a little caramelized. Do not stir during the first 2 minutes. Serve hot on the toasted brioche, with a final dredging of confectioner's sugar.

Serves 4

4 to 6 crisp eating apples,
such as Granny Smith's,
peeled, cored, and quartered
2 tsp lemon juice
4 tbsp unsalted butter, plus
extra for spreading
$1/3$ cup superfine sugar
4 slices of fresh brioche
confectioner's sugar for
dredging
small pinch of ground
cinnamon
2 tbsp raisins, first soaked in
brandy, Calvados, or apple
brandy, if you like

GELEE DE GROSEILLES

RED CURRANT JELLY

Makes about 2 lb red
currant jelly

*3½ lb ripe red currants
about 2½ lb superfine sugar,
more if needed*

Groseilles *Le Boisseau juillet 93 . . .* I still have one precious pot of last July's red currant jelly *maison* in my London store cupboard. Stuck as it is between store-bought acacia honey and a jar of superfine sugar with 2 vanilla beans, it is not quite the row of neatly labelled jars of jams and jellies that I remember seeing in my grandmother's larder. But it is still satisfying and I know it tastes deliciously tangy and fruity in the way that only home-made preserves can. It also makes a very suitable glaze for open fruit pies and a delicious filling for plain cakes. Served with a slice of fresh brioche or pound cake, and a ladleful of Crème Anglaise or Chantilly, it completes a delectable classic trilogy.

The following recipe is easy and works well with other pectin-rich fruit and berries: black currants, blackberries, blueberries, and also apples and quince if you have a juice extractor.

★ Prepare the red currants. Working over a large saucepan, run the tines of a fork down each cluster to separate the red currants from the stalks. Discard the stalks.

Add 4 to 5 tablespoons of water to the red currants and bring to a simmer over moderate heat, stirring and mashing the currants with the back of a large wooden or slotted spoon.

Once all the currants have burst and released their juice, remove from the heat and leave until cool. Strain the mixture: using a large very fine strainer, allow the juice to drip into a measuring jug, without pressing it through.

Measure the liquid. For each 2 cups strained juice, you need to use 1 lb superfine sugar.

Rinse the pan. To set the jelly, return the juice to the pan and stir in the required amount of sugar. Set the pan over low heat and stir until the sugar has dissolved. Turn up the heat, bring to a boil, stirring occasionally, then stop stirring and boil for 3 minutes. Check that setting point has been reached by putting a teaspoon of jelly on a saucer. Leave to cool for 2 minutes, then push the surface with your finger – it should wrinkle a little. If not, boil for another minute or two.

Ladle the jelly into sterilized screw-top jars. If you like, cover with a disc of waxed paper. Leave to get cold, then cover with the lid and store in a cool place until required.

COMPOTE D'ABRICOTS ET DE NECTARINES

POACHED APRICOTS AND NECTARINES IN A LIGHT SYRUP

Serves 4 to 6

1 lb firm ripe apricots
3 nectarines
1/4 cup superfine sugar
pinch of ground cinnamon
2 tbsp apricot jam
2 tbsp kirsch
2 to 3 tbsp lemon juice
crème fraîche or thick plain
yogurt, to serve (optional)
French Pound Cake (page
43) or Sweet Plain Cookies
(page 56), to serve (optional)

Bring a saucepan of water to the boil. Add the apricots and return to the boil over moderate heat. Add the nectarines, reduce the heat, cover, and simmer gently for 3 to 5 minutes.

Meanwhile, in a second saucepan, bring 1 cup water to a simmer with the sugar and cinnamon, stirring frequently.

Lift 1 apricot from the pan with a slotted spoon and test that the skin peels easily with a small sharp knife – if not, return to the pan for 1 minute longer.

Drain the fruit, leave to cool for a few minutes, then peel. Cut in half and remove the pits.

Put the apricots in the simmering syrup. Reduce the heat and poach in barely simmering liquid for 3 to 4 minutes until just tender but not too soft, turning the fruit over a few times.

Using a slotted spoon, transfer the fruit to a serving bowl. Divide the halved nectarines. Stir the apricot jam and the kirsch into the syrup. Pour over the fruit. Add the lemon juice, toss lightly and leave to cool. Refrigerate for at least 1 hour. Serve chilled with, if you like, crème fraîche or thick plain yogurt, cake or cookies.

TARTELETTES AUX FRUITS

INDIVIDUAL FRUIT TARTS

These pretty little tartlets are best simply filled with a mixture of seasonal fruit. Bake ahead of the meal and pop under the broiler to caramelize at the last minute.

★ Prepare the pastry cases. Heat the oven to 400°F. Grease and flour a baking sheet.

Using a large cookie cutter, cut out four 4 in circles of the chilled pastry. Place these on the prepared baking sheet. Pinch up the edge of each circle to make a rim and pierce all over (both base and rim) with a fork at regular intervals.

Brush the pastry with egg white. Bake for 10 minutes, then reduce the heat to 375°, and bake for another 5 to 10 minutes until crisp and cooked through. Cover loosely with foil if the pastry is browning too much after 5 minutes.

Remove from the oven and leave to cool. In a small saucepan very gently heat the apricot jam, red currant jelly, or marmalade until soft and runny.

Brush lightly over the pastry base avoiding the rim. If you like, spread a tablespoon of Crème Pâtissière over the glaze. Arrange the fruit on top and brush a little more glaze over the fruit.

Heat the broiler to high. Broil the tartlets for about 5 minutes, until caramelized. Serve warm rather than piping hot.

Serves 4

½ lb store-bought chilled shortcrust pastry sheet about 2 tbsp unsalted butter for greasing all-purpose flour 1 small egg white, lightly beaten

For the topping:

½ cup apricot jam, red currant jelly (page 18), or marmalade ¼ cup thick Crème Pâtissière (page 24), optional about 1¼ lb prepared fruit: hulled strawberries, grapes, raspberries, pitted cherries, ripe apricots, or plums, halved or quartered

CREMES ET SAUCES

CREAMS AND SAUCES

CREME PATISSIERE

CONFECTIONER'S CUSTARD

Serves 4

3¹/₂ cups milk
1 vanilla bean, split
lengthways or a few drops of
vanilla extract
1 very fresh large egg and 3
very fresh large egg yolks
¹/₃ cup superfine sugar, more
if preferred
¹/₄ cup all-purpose flour
1 tbsp chilled butter, cut into
slivers

For a more airy cream, whisk 1 large egg white until stiff, stir in 1 tablespoon of superfine sugar and beat into the simmering cream at the end of cooking.

★ In a saucepan, slowly bring the milk to almost boiling point over low heat with the vanilla flavoring. Turn off the heat and let the flavored milk infuse for 10 minutes, or longer still if you are using a vanilla bean.

Meanwhile, in a large bowl, whisk together the egg, egg yolks, and the sugar until the mixture is frothy, smooth, and pale.

Sift in the flour, a little at a time, stirring vigorously until well mixed.

Return the milk to a simmer. Remove the vanilla bean, if using, then pour the simmering milk into the egg mixture a little at a time, whisking well until smooth and blended.

Pour the mixture back into the pan, place over low heat, and bring to the boil, stirring constantly. Simmer for a few minutes, stirring constantly until thickened a little.

Remove from the heat. Whisk in the butter, a sliver at a time. Leave the cream to get cold, giving it a stir occasionally to stop a skin forming. Refrigerate until ready to serve.

CREME CHANTILLY

FLAVORED WHIPPED CREAM

I am not a great believer in abandoning the table to cook between courses, but I make an exception for delicious old-fashioned Crème Chantilly. A quick and easy treat, it seldom fails to bring out the *gourmand* in people. The secret of success is to start with well-chilled cream in an icy bowl.

★ Put the cream in a bowl, cover, and refrigerate until well chilled. Add the sugar and the flavoring (if using) to the chilled cream.

Using a hand-held electric whisk, whip the sweetened cream, starting slowly, then increasing the speed, until the cream is frothy and very firm. Do not overbeat until the cream separates into buttery granules. Fold in the ice water and serve immediately. Crème Chantilly will keep chilled for a couple of hours but it best served as soon as possible.

Serves 4 to 6

1¾ cups thick heavy cream
confectioner's sugar to taste
1 to 2 tsp kirsch or brandy
(optional)
1 tbsp ice water

SAUCE A L'ABRICOT

APRICOT SAUCE

B lanch and peel the apricots as explained on page 20. Now remove the pits. Chop the apricots and mango and collect the juices. Put in the blender or food processor and blend until smooth.

Stir in the lime juice and the kirsch or Cointreau. Whisk for a minute, then stir in confectioner's sugar to taste. Serve hot, warm or chilled, whisking again at the last minute.

Makes at least 1½ cups

1 lb very ripe apricots
1 very ripe mango
juice of 1 lime
1 tbsp kirsch or Cointreau
confectioner's sugar to taste
(optional)

CREME ANGLAISE

CUSTARD CREAM

Serves 4

*2½ cups milk
2 vanilla beans, split
lengthways or a few drops of
vanilla extract
3 very fresh large egg yolks
5 to 6 tbsp superfine sugar
¼ cup light cream (optional)*

T he basis of many an ice cream, the coating for puddings, Crème Anglaise is a wonderfully versatile and useful custard cream. If you like, flavor the milk before infusing with a few tablespoons of strong black coffee or liquid caramel, a little finely grated orange or lemon zest, a dash of fruit liqueur, or rum.

For a thicker cream, use an extra egg yolk or two. If you like, stir a scant teaspoon of cornstarch or potato starch into the yolk and sugar mixture before whisking in the flavored milk – this will help keep the custard free of lumps.

★ Bring the milk to boiling point with the vanilla flavoring in a saucepan over low heat. The moment it starts bubbling, turn down the heat, and continue to simmer and infuse for a few minutes. Remove from the heat.

In a large bowl, whisk together the egg yolks and sugar until frothy, smooth and pale.

Remove the vanilla beans from the milk. Stirring constantly, pour the hot milk, a little at a time, over the egg yolk and sugar mixture.

Pour the mixture back into the pan and return to very low heat. Bring almost, but not quite, to boiling point, stirring all the time with a large wooden spoon. The cream will thicken gradually and it will be ready when it coats the back of the spoon. Do not let it boil and remove it from the heat occasionally while it is cooking.

Strain the custard through a fine strainer into a cold bowl. Stir occasionally as it cools. For a finer texture, stir the cream into the cold custard.

SAUCE AU CHOCOLAT NOIR

DARK CHOCOLATE SAUCE

Serves 4 to 6

2 tbsp unsalted butter
4 oz dark semi-bitter
chocolate, broken into small
pieces
3 tsp confectioner's sugar
1 tbsp light cream
1 tbsp Cointreau, brandy,
rum, or whisky (optional)
1 tbsp finely grated unwaxed
orange zest (optional)

The flavor of this simple sauce depends almost entirely on the chocolate you use. Made with high cocoa-bean content, top quality bittersweet chocolate, this richly glossy sauce is perfect for coating cakes and serving with ice cream. It can turn an ordinary dessert into a class act. For a looser, sweeter texture, add a little more cream and sugar. Break the chocolate into even-sized small squares before melting and do not overcook. If you like, replace the sugar with apricot jam.

★ Melt the butter over low heat in a small saucepan. Add the chocolate pieces, about 5 to 6 tablespoons of water and the sugar. Reduce the heat and stir regularly until the chocolate has melted.

Once the chocolate has melted, stir in the cream and the flavoring, if using. Serve hot.

CARAMEL

COATING CARAMEL

3½ oz superfine sugar
3 to 4 tbsp water
a few drops of lemon juice or
vinegar

Remove the boiling syrup from the heat the moment it turns golden. It will be perfect for coating fruit, sweet choux buns (page 44), and the inside of baking molds.

★ Put the sugar and the water in a small heavy saucepan. Melt the sugar over moderate heat, tilting the pan over the heat from side to side, and stirring occasionally to cook evenly. Keep a constant eye on the mixture.

Bring to boiling point, then completely stop stirring, and leave the syrup to boil until it becomes golden.

To keep the syrup liquid and at coating temperature, sprinkle in a few drops of lemon juice or vinegar and work swiftly. Remove from the heat. Dip the ingredients into the syrup that you want to coat, then drain them well, and leave to set on a rack placed over a plate.

If you want to coat the inside of a mold, pan or dish, first warm the container. Pour in the liquid caramel, tilt from side to side until evenly coated, then invert over a rack and leave to set.

COULIS DE FRUITS ROUGES

RED BERRY SAUCE

If you want to add black and red currants, pitted cherries, blueberries, or cranberries, add extra sugar and cook the purée for a few minutes longer until soft.

★ Put the berries and the superfine sugar in a saucepan. Add 6 tablespoons of water and bring to a simmer over moderate heat.

Remove from the heat and leave to cool for a few minutes. Process for a few seconds in a blender or food processor.

Push the warm purée through a fine strainer into a bowl. Taste and adjust the sweetness level with confectioner's sugar. If you like, stir in a little black currant liqueur, brandy or orange and lemon juice. Serve warm or chilled.

Makes about 1½ cups

about 1½ lb mixed ripe raspberries, blackberries and strawberries
3 to 4 tbsp superfine sugar
confectioner's sugar to taste
One of the following, to flavor: 2 tbsp black currant or raspberry liqueur, 1 tbsp brandy, 1 tbsp each orange and lemon juice

TARTES

TARTS

TARTE TATIN MAISON

QUICK UPSIDE-DOWN APPLE TART

Serves 4 to 6

*1½ lb crisp eating apples
such as Granny Smith's
4 oz unsalted butter, plus
extra to caramelize
1 cup superfine sugar, plus
extra to caramelize
½ lb store-bought chilled
shortcrust pastry sheet
2 tsp apple brandy (optional)*

Caramelized upside-down apple tart, the great invention of the legendary Tatin sisters who first concocted it in their restaurant not far from Orleans, is one of the best-loved of all French desserts. I will always remember my niece Clémence, a *gourmande* after my own heart, asking for Tarte Tatin in a restaurant in Brittany within seconds of opening the menu. She was 7 at the time. Her reading was more fluent than I had given her credit for; it did say in very small print that you had to order hot desserts at the beginning of the meal . . . The recipe below uses store-bought pastry and is a tried and tested quick version of Tarte Tatin. Bake the tart when it is most convenient for you and finish it off under the broiler just before eating as Tarte Tatin does not have to be piping hot; just warm will do very well. We tend to serve Tarte Tatin on its own at home in France, but a well-heaped spoonful of vanilla ice cream or creamy yogurt is a distinct possibility. Ripe pears also 'tatin' well but beware of apricots, peaches, and nectarines which are too watery and collapse and ooze after cooking . . .

★ Put a large baking sheet in the oven and heat to 400°F. Generously butter the base and the sides of a large loose-bottomed tart pan. At this stage, reserve a heaped tablespoon of butter.

Sprinkle sugar all over the pan: it should be generously and evenly coated. Reserve two tablespoons of sugar.

Peel the apples if you like. Alternatively, rinse and dry with paper towels. Now core and quarter the prepared apples. If they are on the large side, cut each quarter in half. Arrange the wedges

tightly in concentric circles in the prepared pan.

Cut the remaining butter into slivers and distribute them over the apples. Sprinkle with the remaining sugar, and with the apple brandy, if you like.

Put the pastry sheet over the apples. Trim it with a pastry cutter or a sharp knife so that it fits the pan – allow plenty of margin, a generous inch of extra pastry. Tuck in the pastry under the apples, working your way round between the apples and the sides of the pan, leaving a small gap between the sides of the pan and the pastry parcel.

Put the pan on the hot baking sheet and bake for about 30 minutes until the pastry is cooked. Check after 15 minutes and reduce the heat if the pastry is browning too fast. After baking, leave to cool in the oven for a few minutes, or until you are ready.

Just before serving, heat the broiler to high. If the pan is still hot, protect your hands with oven gloves. Put a flameproof serving dish over the pastry and turn the tart upside down on the dish. Remove the ring and base. If the apples look a bit untidy rearrange the topping a little.

Now dot a few small pieces of extra butter over the apples. Sprinkle lightly with sugar. Reduce the heat and broil for a few minutes until the apple topping begins to bubble and caramelize. You may need to turn the dish around to ensure even coloring. Serve immediately.

TARTE AU CITRON
LEMON TART

Serves 6

For the sweet shortcrust
pastry case:

1 large egg
¼ cup superfine sugar
a small pinch of salt
2 cups all-purpose flour, plus
extra for flouring
10 tbsp softened unsalted
butter, plus extra for
greasing
2 to 3 tbsp ground almonds

This sweet tart has a pronounced tang of sharp lemon – for a sweeter flavor, use only 2 lemons and an extra tablespoon of orange zest as well as 2 tablespoons of orange juice for the filling. Thin orange slices cooked in syrup can be used with the lemon for the topping.

★ Prepare the pastry case. In a bowl, whisk the egg with the sugar and a small pinch of salt until the mixture is frothy and pale.

Sift the flour into another bowl, then add to the egg and sugar mixture. Work the mixture lightly with your fingertips until it has the texture of coarse sand.

Work the butter into the flour mixture until it is absorbed. Form the pastry into a ball, cover with plastic wrap and refrigerate for at least 40 minutes.

Dredge a rolling pin with flour and generously grease a loose-bottomed tart pan with butter.

Roll out the pastry and line the prepared pan, use your hands to fit the fragile short pastry into the pan. Pierce at regular intervals with a fork. Spread the ground almonds over the pastry. Press in lightly. Chill while you prepare the filling.

Heat the oven to 375°F. Beat the butter with the sugar until the mixture is smooth and light. Stir the grated zest and the lemon juice into the butter mixture. In a bowl, beat the eggs as for a fluffy omelette. Stir this into the flavored butter, working lightly and swiftly.

Pour the filling into the prepared pastry case and bake for about 35 to 40 minutes, until the filling is set and the base cooked. Leave the tart to cool before you separate off the ring from the base.

If you like, prepare the lemon slices for the topping while the tart is cooling. In a saucepan, mix the sugar with ⅔ cup water. Bring to the boil, then reduce the heat, and stir until the sugar is dissolved. Add the lemon slices to the light syrup and simmer gently over low heat for 5 to 7 minutes until softened.

Remove with a slotted spoon, drain well. Arrange the lemon slices on top of the tart in a loose circular pattern. Serve at room temperature or chilled. If you like, dust lightly with confectioner's sugar at the last minute.

For the filling:

½ cup softened unsalted butter
¾ cup superfine sugar
1 tbsp finely grated unwaxed orange zest
finely grated zest and the juice of 3 unwaxed lemons
3 very fresh large eggs

For the lemon topping (optional):

1 unwaxed lemon, very thinly sliced, pips removed
3 tbsp superfine sugar
1 tbsp marmalade
1 tbsp Cointreau, or other orange liqueur
confectioner's sugar to taste

TARTE AUX NOIX ET AU CHOCOLAT

CHOCOLATE WALNUT TART

Serves 6

*½ lb sweet shortcrust pastry
(see page 34), baked in a
loose-bottomed tart pan
a little egg yolk, for glazing
5 oz fresh walnut kernels
6 oz good-quality bittersweet
dark chocolate, broken into
pieces
3 tbsp softened unsalted
butter
1 very fresh large egg, plus
an extra white
confectioner's sugar to taste
Crème Chantilly, to serve
(page 25), if you like*

This tart was re-created from rather vague instructions I got from an old friend-of-a-friend whose *tarte aux noix* I had enjoyed in a village near Cahors in the Lot. She was of the "small glass of this, finger width of that, hazelnut of this and that" school of recipe-giving so this is an approximation of the original. The light whipped cream may seem excessive but contrasts very nicely with the close texture of the pie.

★ Make and chill the pastry as described in the recipe for lemon Tart (page 34). Grease a loose-bottomed tart pan. Roll out the pastry and spread it into the pan, pressing it in gently with your hands without stretching it, then prick all over with a fork. Refrigerate for 10 minutes. Heat the oven to 375°F. Cover the base of the pastry case with a circle of parchment paper or greased foil. Brush the edges with a little egg yolk mixed with a teaspoon or two of water. Fill with dried beans and bake for 25 to 30 minutes, until the pastry is crisp and the edges are golden.

Leave to cool a little, then remove the beans and the lining. If the center and underside of the pastry is not quite cooked, return it without the lining to the oven for a few minutes. Leave to cool while you prepare the filling.

Select and reserve the more attractive half of the walnut kernels to put on top of the tart. Blend the rest of the walnuts in the food processor until smoothly ground.

In a saucepan, melt the chocolate pieces with a little butter and about 5 tablespoons of water over low heat. Take off the heat, stir in the remaining butter (reserving a pat to sauté the walnut kernels for the topping), then the egg yolk and the ground walnuts. Sweeten to taste with confectioner's sugar.

Whisk the egg whites until soft peaks form, then fold this into the chocolate mixture.

Spoon this filling into the prepared pastry case, spreading it evenly. Refrigerate for at least 15 minutes. Meanwhile, put the rest of the butter in a small saucepan. Melt over moderate heat. Add the reserved walnut kernels, dredge with confectioner's sugar, and sauté for 1 to 2 minutes. Spread over paper towels and leave to cool. Take the tart out of the refrigerator, arrange the walnut kernels on top. Refrigerate again for at least 20 minutes or until set.

Serve cold and, if you like, dredged with confectioner's sugar and with a bowl of Crème Chantilly (page 25).

GATEAUX

CAKES

GATEAU A L'ORANGE

ORANGE-FLAVORED CAKE

Serves 6 to 8

*⅓ cup superfine sugar
6 tbsp softened unsalted
butter, plus extra for
greasing
3 very fresh eggs
1 cup self-rising flour
1 scant tsp baking powder
2 tbsp finely grated zest of
unwaxed orange
1 tbsp orange flower water
2 tsp Cointreau (optional)*

For the coating:

*2 tbsp orange marmalade
1 tbsp lemon juice
¼ cup orange juice
2 tbsp Cointreau
⅓ cup confectioner's sugar,
plus extra for dredging*

S lightly moist and delicately flavored, this cake has been a family favorite for decades. Indeed, a hand-written version of the recipe was part of the cookery survival kit a kindly aunt felt I needed to survive at university amongst *les Anglais* . . . Over the years it has gradually mellowed into something more orangey and alcoholic than the original.

★ Heat the oven to 350°F. In a bowl, whisk the sugar and butter until pale and creamy. Beat the eggs into the mixture, one at a time, working in each before adding the next.

Sift the flour and baking powder over the mixture and fold them in lightly and quickly. Stir in the grated zest, the orange flower water, and the Cointreau, if you like, into the mixture.

Generously grease a 1¼ quart loaf pan. Spoon in the mixture. Knock the pan against the work surface to settle the contents.

Bake for about 50 minutes, until the cake is firm but bounces back a little when you press it gently. A metal skewer inserted into the center of the cake should come out clean. If not, turn up the heat a notch and bake for another few minutes.

Leave to cool in the pan for about 10 minutes, then carefully ease the cake out of the pan and place on a serving dish.

Prepare the coating while the cake is still warm. In a saucepan, over low heat, gently warm the marmalade, orange, and lemon juice with the Cointreau. Stir in the confectioner's sugar and stir until you have a smooth syrupy mixture.

Using a pastry brush, paint this syrup over the cake: it will sink in and add flavor. Wait until cold to serve. Dredge with confectioner's sugar at the last minute.

GATEAU AUX NOISETTES
HAZELNUT CAKE

Heat the oven to 350°F. Coarsely chop a handful of hazelnuts and reserve. Finely chop the rest or blend for a few seconds in the food processor.

In a bowl whisk the sugar with the egg yolks until smooth and pale. Stir in the ground hazelnuts, then add the cornstarch and baking powder. Fold well in, working with light swift movements.

In a separate bowl whisk the egg whites with a pinch of salt until stiff, then fold into the mixture, using a large metal spoon. Work in the whites lightly with upward movements until absorbed.

Grease with butter then dredge with flour a deep tart pan or other round cake pan. Pour in the cake mixture, knock the pan once or twice against the work surface to settle the contents.

Bake for about 40 to 45 minutes until the cake is cooked through and bouncy firm to the touch. Leave to cool for 5 minutes, then turn out onto a cooling rack and leave until cold.

Serves 6

²/₃ cup superfine sugar
3 very fresh eggs, separated
½ lb fresh shelled hazelnuts
⅓ cup cornstarch
1 scant tsp baking powder
1 tbsp all-purpose flour, for
flouring
pinch of salt
butter for greasing

For the filling:

5 to 6 tbsp apricot jam

For the coating:

3 oz good-quality light or
semisweet chocolate, broken
into small pieces
2 tbsp light cream
2 tbsp unsalted butter

Make the filling: melt the apricot jam in a saucepan until runny. Stir in the reserved chopped hazelnuts. Carefully cut the cake horizontally in half. Spoon the filling over the bottom half, spreading it evenly. Put the other half on top to sandwich the cake back into its original shape.

Now make the coating. In a small saucepan, put the chocolate pieces, 3 tablespoons of water, the cream, and the butter. Heat slowly over very low heat, stirring constantly with a wooden spoon, until the chocolate has smoothly melted and blended with the other ingredients.

Place the cooling rack with the cake over a plate. Spoon or pour the melted chocolate over the center of the cake and spread it evenly over the top and sides of the cake with a flexible spatula. Leave to set and get cold before serving.

QUATRE-QUARTS

FRENCH POUND CAKE

Serves 6

2 large eggs
½ cup superfine sugar
1 tbsp finely grated zest of unwaxed lemon
1 tbsp finely grated zest of unwaxed orange or 2 tbsp orange flower water
11 tbsp unsalted butter
1¼ cups self-rising flour
1 tbsp ground almonds or hazelnuts

With more or less equal amounts of egg, butter, sugar, and flour – the four quarters referred to in its name, French pound cake is a family dessert often served with stewed fruit, fruit salad, or as a mid-afternoon *gâteau*.

★ Heat the oven to 350°F. Beat the eggs with the sugar and the grated zest and/or orange flower water until the mixture is pale and frothy.

Put the butter in a loaf pan and put it in the oven until almost melted. Tilt the pan until evenly coated with butter, then gradually pour the melting butter into the egg mixture, working it in a little at a time, until completely absorbed.

Reserving a scant tablespoon for flouring the pan, sift the remaining flour over the mixture, a little at a time, folding it in gently with a metal spoon. Now mix in the ground almonds or hazelnuts.

Dredge the pan with a little flour, pour in the cake mixture and spread in evenly. Bake in the oven for 35 to 45 minutes. Check after 20 minutes; if the top of the cake is browning too fast, cover it with a piece of foil. Before you switch off the oven, make sure that the cake is thoroughly cooked by inserting a skewer – it should come out clean and dry. If not, return to the oven for 5 to 7 minutes.

Invert the cake onto a cooling rack and leave to get completely cold before serving. The cake will keep well for a few days wrapped in foil and refrigerated or in a cool place.

SAINT-HONORE

ST HONORÉ'S CAKE

Serves 6

*1/2 lb shortcrust pastry
(see page 34), chilled and
ready to roll
butter for greasing
flour for flouring
1 1/2 tbsp superfine sugar
1 tbsp ground almonds*

For the choux paste:

*3/4 cup water
4 tbsp butter
pinch of salt
3/4 cup all-purpose flour,
sifted
3 very fresh eggs
a few drops of vanilla extract
Caramel Coating (page 28)
2 cups Crème Chantilly
(page 25)
1 generous tbsp chocolate
shavings, to scatter over
the cake*

This traditional festive Parisian cake is named after Saint Honoré, patron saint of bakers and pastry cooks whose *fête* is celebrated on May 16th. Crème Pâtissière lightened with whisked egg white (page 24) is another classic filling for this delicious concoction. The choux paste can be prepared the day before and chilled, as can the circle of shortcrust pastry.

For a less complex but always popular dessert for 4 people, serve the choux puffs on their own as *profiteroles.* After the caramel has set, slit the choux and fill them with Crème Chantilly (page 25), Vanilla Ice Cream (page 49) or Crème Pâtissière (page 24). Serve at once, with hot Dark Chocolate Sauce (page 28).

★ Grease two baking sheets. Using a floured rolling pin and a floured cold work surface, roll out the shortcrust pastry dough into a thin circle, about 9 in in diameter. Dredge with superfine sugar and ground almonds, then press these in lightly with your hands. Put the circle on 1 of the prepared baking sheets and refrigerate for at least 15 minutes.

Make the choux paste. Bring the water, butter and salt to the boil in a saucepan. Remove the boiling liquid from the heat, add the sifted flour, and quickly work it into the liquid with a spatula or wooden spoon.

Return to the heat for a minute and stir briskly until the paste comes off the sides of the pan in a ball. Now beat in the eggs one at a time until the paste is supple, elastic, and glossy. Beat the last egg in a cup before adding it in and save a little for glazing. Flavor the paste with a few drops of vanilla extract.

Heat the oven to 400°F. Fit a pastry bag with a plain $\frac{1}{2}$ in tip and stand the bag in a jar. Spoon the paste into the bag (don't fill up but proceed in stages). Pipe a ring around the chilled pastry circle about $\frac{1}{4}$ in from the edge.

Use the rest of the paste to pipe small walnut-sized balls on the second baking sheet, keeping them at least $\frac{3}{4}$ in apart. Brush the outside edge of the pastry, and the choux paste circle lightly with glaze.

Bake for about 25 minutes, opening the oven door for the last 3 minutes, until firm and dry. Pierce the choux ring and buns with a metal skewer and leave the lot to cool on a rack.

Once the cake is well cooled, prepare the caramel syrup as described on page 28. Quickly and carefully dip the choux puffs upside down in the syrup, using a metal skewer or fork, then arrange them right way up and side by side on top of the choux paste ring. Leave to set in a cool place.

Just before serving, whip up the Crème Chantilly. Spoon into the center of the cake and scatter over chocolate shavings. Serve as soon as possible, or keep refrigerated for up to 1 hour until ready to serve.

GLACES MAISON ET RECETTES PREFEREES

HOMEMADE ICE CREAMS AND FAVORITE RECIPES

GLACE AU CASSIS

BLACK CURRANT ICE CREAM

Serves 4 to 6

*about 2 lb ripe black
currants
confectioner's sugar to taste
2 tbsp crème de cassis
(black currant liqueur)
(optional)
about 1½ cups mixture of
thick plain yogurt, cream,
and fromage blanc
Sweet Plain Cookies, to
serve (page 56) if liked*

The business of rushing to the freezer to take the ice cream out for whisking is a tedious one and I used to make a limited amount of ice cream over the summer until . . . I acquired an ice cream maker. It is lovely to hear it churning away (in the garage because it is incredibly noisy) while we enjoy our meal and know we will have a light airy fruit ice at the end of it . . .

If you don't have an ice cream maker, use heavy cream only and take the ice cream out of the freezer for whisking at regular intervals as described in the earlier recipes. The Red Berry Sauce on page 29 also makes a good ice cream base.

★ Prepare the black currants: working over a large saucepan, use the tines of a fork to separate the black currants from the stalks. Discard the stalks.

Add 4 to 5 tablespoons of water and bring to a simmer over moderate heat, stirring and mashing the currants with the back of a large wooden spoon.

Once all the currants have burst and released their juice, strain the mixture through a large very fine strainer into a bowl, pushing well with the back of the spoon. Sweeten to taste with sugar. If you like, flavor with a little crème de cassis.

Leave the fruit sauce to get cold. Whisk the yogurt, cream, and fromage blanc until smoothly blended. Whisk in the fruit. Taste and adjust the flavoring.

Pour or spoon into the ice cream maker and churn until softly frozen: it should scoop out easily. Serve immediately, with Sweet Plain Cookies (page 56), if you like.

GLACE A LA VANILLE

VANILLA ICE CREAM

Using the method described on page 26, make a well flavored thick Crème Anglaise. Strain it through a fine strainer and stir it frequently while it gets cold.

★ Whisk the heavy cream until firm. Carefully fold into the cold custard. Flavor with a little extra vanilla extract if you like.

Pour the mixture into a suitable container and freeze. After about 40 minutes, remove the container from the freezer, spoon the contents into a bowl and whisk vigorously to prevent crystals forming. Pour back into the container and return to the freezer. Repeat the process twice, at half-hourly or so intervals, then leave the ice cream in the freezer until completely frozen.

Remove the container from the freezer about ten minutes before serving: the timing will depend on the room temperature. Spoon into individual dessert dishes or glasses. If you like, serve the vanilla ice cream with Red Berry Sauce (page 29) or with fresh berries.

Serves 4

¾ cup chilled heavy cream
Red Berry Sauce (page 29) or
fresh strawberries and
raspberries, to serve,
if you like

For the Crème Anglaise:

1½ cups whole or
low-fat milk
3 split vanilla beans or
several drops of
vanilla extract
4 large or 5 medium
egg yolks
½ cup superfine sugar

GLACE PRALINEE

ICE CREAM WITH GROUND ALMONDS

Serves 6

about 2½ cups Vanilla Ice Cream (see page 49)
2 tbsp unsalted butter
about 2 tbsp each slivered almonds and chopped fresh hazelnuts
2 tbsp slightly stale brioche crumbs
3 tbsp superfine sugar, plus extra to finish
1 tbsp brandy (optional)

Praline is a tooth-breaking confectionery, a bumpy little *bonbon* made of caramelized almond. *Pralin* is the same preparation ground to sweet nutty crumbs. Named after Kings Louis XIII and XIV's great minister Marshall Duke of Choiseul, Count of Plessis-Pralin, it was in fact the creation of his chef Lassagne and an instant gourmet hit with the French court. Poor Lassagne never got much direct credit for his invention; after he left Choiseul's employ, he retired to Montargis not far from Orléans. The town wasted little time in adopting praline as its own local *specialité*.

The brioche crumbs and brandy I use are not classic components of praline but I think they do add a little *je-ne-sais-quoi* to the ice cream.

★ Prepare Vanilla Ice Cream as described on page 49. Pour the mixture into a suitable container and freeze.

Meanwhile, prepare the ground almond mixture: melt the butter over low heat in a frying pan.

In a cup, mix the slivered almonds, chopped hazelnuts, brioche crumbs, and sugar. Spread the mixture over the melted butter. Turn up the heat a fraction and sauté for a few minutes, stirring and shaking the pan, until the mixture is golden and caramelized.

Sprinkle in the brandy, if you like, and a little extra sugar. Sauté for a minute or two. Remove from the heat, cool a little, then blend in the food processor until minced.

After about 40 minutes, remove the container from the freezer, spoon the ice cream into a bowl, and whisk vigorously to prevent crystals forming. Whisk in the caramelized ground almond mixture. Pour back into the container and return to the freezer. Repeat the process after 40 minutes, then again twice, at half hourly or so intervals, then leave the ice cream in the freezer until completely frozen.

Remove the container from the freezer about 10 minutes before serving: the timing will depend on the room temperature. Spoon into individual dessert dishes or glasses. If you like, sprinkle each serving with more praline mixture.

GATEAU AU CHOCOLAT DE LA FAMILLE

CHOCOLATE CAKE

Serves 6 to 8

*8½ oz good-quality
bittersweet dark chocolate
⅔ cup superfine sugar
10 tbsp unsalted butter, cut
into small pieces, plus extra
butter for greasing the pan
3 heaped tbsp self-rising
flour
1 heaped tbsp fresh bread
crumbs
4 very fresh eggs
1 tbsp grated zest of
unwaxed orange
small pinch of salt*

To coat:

*Dark Chocolate Sauce
(page 28)*

Moist, solid, dark, and generously coated, this is my state-of-the-art version of the chocolate cake that I was brought up with. The rest of the family still bakes it in their various kitchens for celebrations and gatherings. The thick and glossy coating has a rich deep chocolate taste and will mask any surface cracks.

★ In a large saucepan, melt the chocolate pieces with the sugar, and 4 tablespoons of water over very low heat, stirring frequently with a wooden spoon.

Remove the pan from the heat and stir in the butter, a piece at a time. Return to low heat. Sift in the flour, stir lightly to mix, add the bread crumbs, mix in and continue stirring for 2 minutes, still over low heat.

Remove the pan from the heat and leave the chocolate mixture to cool a little. Heat the oven to 350°F. Butter a loaf pan or round cake pan. Line the base with buttered parchment paper.

Separate the eggs. Put the whites in a large bowl and set aside. Stir the yolks one by one into the chocolate mixture, beating each in completely before adding the next. Stir in the zest.

Add a small pinch of salt to the egg whites, then whisk them until they are stiff.

Using a large metal spoon, fold these into the chocolate, but working swiftly with upward movements to keep in the air.

Add the chocolate mixture to the prepared pan. Spread with a spatula, knock the pan on the work surface to ensure there are no large air bubbles.

Bake for about 45 minutes. After about 25 minutes, open the oven door and check that the cake is baking evenly. Turn up the heat to the next setting for the last 5 minutes of cooking. The cake will be ready when it is bouncy firm to the touch and when a small sharp knife blade inserted into it comes out clean and dry.

Leave to cool in the pan for several minutes, then carefully ease out the cake onto a cooling rack. Leave to get cold. Wait until the cake is cold before coating it with Dark Chocolate Sauce (page 28).

ILE FLOTTANTE

FLOATING ISLAND

Serves 4 to 6

*2 tbsp melted unsalted butter
and 2 tbsp superfine sugar,
for the mold
3 large or 4 medium egg
whites
1 cup superfine sugar
6 sugared almonds and 3
small dry macaroons,
crushed
Caramel (page 29)*

To serve:

*Crème Anglaise (page 26)
or/and Red Berry Sauce
(page 29)*

With its golden caramel coating, this wonderfully fluffy meringue dessert is best prepared well in advance and left to infuse in the refrigerator. If you have the time and energy, serve it with both custard and fruit sauce for a truly glorious combination of flavors, colors, and textures.

★ Prepare the mold. Warm a 1½ quart ring mold, cake pan or charlotte mold. Brush the inside with melted butter and dust with superfine sugar. Stand upside down on a plate and set aside.

In a bowl, mix the crushed sugared almonds and macaroons. Heat the oven to 325°F.

In a large bowl, whisk the egg whites with a pinch of sugar until stiff, then whisk in the sugar, a little at a time, until the meringue is satiny. Swiftly whisk in the crushed sugared almonds and macaroons.

Prepare a bain-marie: bring a pan of water to the boil. Line

the base of a large roasting pan with a thick layer of old newspapers.

Spoon the meringue mixture into the prepared mold, spreading it in evenly. Put the mold in the center of the lined pan. Pour boiling water into the pan to come nearly halfway up the sides of the mold.

Put the bain-marie in the oven and bake the meringue for about 40 minutes, until puffed up and firm, keeping an eye on the bain-marie. Pour in extra boiling water if necessary.

Remove from the oven. Leave the meringue to cool and shrink back before unmolding it onto a serving dish.

Make the caramel (see page 28). The moment it is ready and golden, pour it over the meringue, letting it drip freely around the sides. Leave to get cold, then refrigerate until ready to serve. Serve chilled, with Crème Anglaise and/or Red Berry Sauce.

PETITS BISCUITS

SWEET PLAIN COOKIES

Makes at least 24 round
cookies

*6 oz unsalted butter, cut into
small pieces, and extra butter
for greasing
⅓ cup superfine sugar
a few drops of almond
extract (optional)
2 cups all-purpose flour,
sifted, plus extra for dusting
1 small egg, plus 1 extra yolk
for glazing*

Put the butter and sugar into the bowl of a food processor fitted with the metal blade. Blend for 15 to 20 seconds, until pale and fluffy. Scrape off the sides of the bowl with a spatula.

Add the remaining ingredients in the bowl. In short bursts, process until the dough comes together in a ball.

Dust the ball of dough with flour, wrap in plastic wrap and refrigerate for at least 30 minutes.

Heat the oven to 375°F. Lightly grease a baking sheet. Dredge a cold work surface, a round 2¼-in cookie cutter and a rolling pin with flour.

Put the dough on the floured surface, roll it out until thin. Stamp out circles of dough with the cookie cutter. Put these on the baking sheet.

In a cup, mix the egg yolk with a teaspoon or two of water. Brush this glaze very lightly on the cookies

Bake for 12 to 15 minutes, until the cookies are lightly colored. Leave in the oven to cool and harden a little, then use a spatula to slide the cookies on to a cooling rack until cold.

LIST OF RECIPES